Site-Specifici

■■■ Black Dog Publishing Limited

ty: The Ethno

graphic Turn

Volume 4

de-, dis-, ex-.

Site-Specificity: The Ethnographic Turn

Edited by Alex Coles

Image project by Lothar Baumgarten: Réalité Silhouettes Paradoxe

10 **Nomads: Figures of Travel in Contemporary Art**
 James Meyer

30 **Lothar Baumgarten: The Seen and the Unseen**
 Anne Rorimer

52 **An Ethnographer in the Field**
 James Clifford Interview

74 **Experience vs. Interpretation:**
 Traces of Ethnography in the Works of Lan Tuazon and Nikki S. Lee
 Miwon Kwon

94 **The Art of Ethnography: The Case of Sophie Calle**
 Susanne Kuchler

114 **Scenes From a Group Show: Project Unité**
 Renée Green

138 **Anthropology at the Origins of Art History**
Matthew Rampley

166 **Sites of Amnesia, Non-Sites of Memory:**
Identity and Other in the Work of Four Uruguayan Artists
Arnd Schneider

182 **An Ethnologist in Disneyland**
Marc Augé

194 **List of Contributors**

accès aux q
Tableaux Paris
noms de mé

M **9**

PONT
DE
SÈVRES

NOUVELLE ÉDITION
REVUE ET AUGMENTÉE
P

LA CONDI
MANU

Nomads: Figures of Travel in Contemporary Art
James Meyer

Within the hodge-podge arena of current practice an identifiable
subset of work has focused on the theme of travel.[1] Unprecedented
mobility and migration, the expansion of multinational companies and
entertainment oligarchies, the spread of communication technologies
and digital networks, the formation of the European Commonwealth
and International Monetary Fund – all of these developments have
propelled a globalisation of culture while provoking nativist fears
and fundamentalist returns, and a grass roots movement critical of
open markets and unchecked 'free' trade.[2] The art world maintains
a tenuous hold on the new internationalism. In a period where the
culture industry is king, the visual arts scene, with its small town
ambience, cult of idiosyncratic personality and attachment to an
artisanal mode of production and display, resembles a kind of guild.
At the same time, the growth of the art fair and the corporate gallery,
of international Biennials and the multinational museum point to
a globalised reception and an increasingly mobile audience; the
aficionado of art must travel from Venice to Münster, from Berlin

de-, dis-, ex-.

to New York in a constant motion in order to 'keep up.' And so it is hardly surprising that this culture of itineracy has influenced the terms of production itself. The effects of this mobility already began to be felt during the 1960s, when the commerce of art and artists between Europe and the US became a daily reality.[3] It was then that On Kawara began to mail his famous postcards from around the world to track his own nomadic existence. Sent to his dealer Seth Siegelaub and other inhabitants of the art scene, On Kawara's cards exposed the expanding parameters of the art world itself. Still others – Richard Long, Andre Cadere and Robert Smithson – applied the serial and 'real time' conventions of 1960s art to record their own bodily movements, while the Situationists developed a practice of mobile intervention within urban settings. In recent years the subjects of travel and the artist-traveller have been explored by younger producers to a remarkable degree. In considering the work of Renée Green, Christian Philipp Müller, Gabriel Orozco and Rirkrit Tiravanija – to my mind the current exemplars of this trend – we discover that a shared subject matter can result in salient differences in method and point of view.[4] The concern of this essay is to point to certain distinctions, or even a divide, within the field of contemporary nomadism. I will argue that essentially two nomadisms have emerged, almost as if in contiguity. The first nomadism is lyrical – a mobility thematised as a random and poetic interaction with the objects and spaces of everyday life. Reconciling the Dada/Surrealist strategy of an arbitrary encounter with the real with a contemporary 'Slacker' feeling of aimlessness, this nomadism transfigures the most ephemeral and incidental contacts for aesthetic contemplation.[5] The second nomadism is critical: it does not enact or record an action or movement for the spectator's delectation, so much as locate travel itself within historical and institutional frameworks. While the one nomadism is personalised, presenting the body's circulations as a series of phenomenological encounters occurring in real time, and tends to veil the material conditions in which this mobility occurs, the other

nomadism locates the mobile self within a periodised, discursive schema: its subjects are the eighteenth century aristocratic tourist, the Romantic Bohemian, the Beatnick, and other archetypal travellers of cultural memory. Where the first activity enacts a nomadic structure in a kind of perpetual present, the second locates incidents of travel in *history*; and if it addresses present-day conditions it does so from the position of a historicising distance.

My own taste sides with the second nomadism; as I will argue, the aim of the first, lyrical nomadism is at odds with the latter's critical intention. The anti-aesthetic impulse to unveil the mechanisms of visual pleasure, a pleasure that confirms the ideology of the beautiful in Western aesthetics and its institutionalisation by the museum and gallery is an old modernist topos. Associated with avant-garde figures like Shklovsky, Vertov and Brecht (who theorised aesthetic estrangement in terms of the strategy of montage) and the Benjamin of "The Author as Producer," the anti-aesthetic impulse resurfaced in the 'dematerialising' Conceptual practices of the late 1960s, the structuralist film criticism of the 1970s, and in the postmodern writings of Craig Owens, Douglas Crimp, Benjamin Buchloh, providing the title of a seminal 1983 anthology edited by Hal Foster.[6] The anti-aesthetic views aesthetic pleasure as a social and above all *historical* effect. One of the concerns of this essay is to valorise this

Rirkrit Tiravanija, *Untitled (Free)*, 1992.
All images courtesy of the artists.

anti-aesthetic impulse of the 1980s and early 1990s, which much recent practice and criticism, it seems, would rather forget.[7] At the turn of the century, 'visual pleasure' and 'uncomplicated optimism' are the signs of prosperous times.[8] It will be my contention that the two nomadisms bear different relationships to the critical legacy of postmodernism and the anti-aesthetic tradition of twentieth century art, even as these practices share a contemporaneity implying an overlap of concerns as well. (There is, perhaps, more criticality in Tiravanija's enterprise and more metaphor in Müller and Green than my somewhat schematic discussion suggests.) Yet, given the preponderance of references to the subject of travel in recent criticism, and the very currency of this work, it would seem useful to view these activities within a framework or field if only to reveal their specificity. For as the structuralists would say, it is only in their differences that these practices make sense.[9]

Rirkrit Tiravanija: I'm interested in roaming the world... I think it's interesting to go physically to places, to put yourself in this little metal thing and shoot yourself through space and time, and then physically be some place with different smells, different....

Rirkrit Tiravanija, *Untitled (From Madrid Airport to Reina Sofia)*, 1994.

Rochelle Steiner: Would you have a destination?

RT: No (laughing), I would just land wherever.[10]

"The particular grain of slack art depends on self-consciously courted chaos" Jack Bankowsky has observed, and indeed *Free*, Rikrit Tiravanija's well-known 1992 installation at the 303 Gallery in New York, was a picture of premeditated disarray.[11] A swarm of pots and pans and tables filled the room, as art lovers eagerly lined up for 'free' plates of Pad Thai. The smell of peanut oil penetrated one's nostrils. Tiravanija's installation/performance was a real time event brought to completion when the food ran out. Some forty years after Happenings and Fluxus Events, critics praise this artist's meals for blurring the gap between art and life as if this were, somehow, new. "Is it art? Of course. Is it life? Definitely: After all, what is life if not a river?"[12] For me, the interest of Tiravanija's project, and its point of contiguity with the work of Green and Müller, is its dramatisation of the artist's own peripatetic existence, its suggestion of a vectored and continuous mobility occurring between countries and institutional settings. Much like Green and Müller, Tiravanija explores an ephemeral or 'functional' site in contradistinction to the site of traditional site-specificity; each of his performances is part of an allegorical chain of reference, a network of previous and future sites through which the nomad-artist circulates.[13]

Gabriel Orozco, *Yielding Stone*, 1992.

A gallerist I know recently characterised Tiravanija as "the most representative artist" of the last decade. I assumed that he was alluding to Tiravanija's practice of artistic nomadism. But my friend was concerned with another aspect of Tiravanija's project. The act of dispensing food, he suggested, was a perfect expression of the present mania for 'generosity.'

What has become of criticality in current practice? 'Visual pleasure' is preferred to clear-minded reflection. Critique has come to seem stodgy, the emotive (once the object of postmodern scorn) has come to seem serious. Displays of sentiment and kindness supplant 'cold' Conceptual, or anti-aesthetic strategies; hard Minimal and Neo-Geo forms are suffused with metaphor and feeling.[14] Tiravanija's collaborative installation with Hans Accola at the Walker Art Center 'liberated' a Flavin relief from its exalted status as formalist art placed at eye level into a low-hung functioning lamp. Hammock chairs arranged below transformed the museum from a supposedly alienating place into a comfortable, messy lounge where one could converse with the artists. Tiravanija's installation at the 1995 Whitney Biennial was also an allegory of 'accessibility.' Together with friends, the artist played play rock 'n' roll before a film of the very paragon of criticality, Marcel Broodthaers, lecturing to a crowd. The audience was invited to grab a guitar and join in too.

Fuck art let's dance (or eat or lie down or chat): this is the casual, Bohemian feeling, the purported good will such work conveys. But what is the nature of its vaunted generosity? What exactly have we eaten? Engaging the audience in a personalised relation with the artist-host, Tiravanija's installations replace the valuable and lasting art commodity with an ephemeral 'gift,' acknowledging the essential human need to consume. Yet this enaction of an actual dinner alludes only obliquely to the mechanisms of exchange of the global art market in which the artist operates: a more pointed critique is avoided.

Gabriel Orozco's *The Yielding Stone* is a ball of grey plasticine. Rolled by Orozco through the streets of New York, the ball, whose

identity is identical to Orozco's, is the record of a lugubrious mobility.
Even more, the stone's porous indexicality has been described as a
metaphorisation of a national and artistic identity that is always in
transition. (Born in Mexico, Orozco has lived in Berlin, Madrid and
New York.)[15] Still other works, such as *Ball on Water* and *Sand on
Table*, suggest a more general transience: the ball pictured will no
doubt float away, the sand on the table will slide off in the wind.
These aesthetically pleasing photographs capture the ephemeral
passage of time, the random experience of the everyday, "the little
nothings of daily life."[16] Reconciling Dada and Surrealist methods of
combination, accumulation and chance with the documentation
techniques of Photoconceptualism, Orozco's practice is visually
arresting and formally complex.[17] But it might legitimately be asked
how Orozco's work addresses, in specific terms, the actual material
situation in which he works. Certain writers have discussed his *Yogurt
Caps* show at Marion Goodman Gallery, 1994, in terms of a strategy
of Institutional Critique. According to this reading Orozco's
substitution of bits of urban detritus for his more visually appealing
works, mounted on the walls of the white cube, exposed a gallery
apparatus dependent on the merchandising of art commodities.
As Jean-Pierre Criqui observed, "If there is an art that Orozco
has mastered, it is that of conforming as little as possible to any
expectation.... In response to the high, overdetermined stakes that a
first show in New York represents... Orozco confounded everyone's
expectations and conceived one of his subtlest pieces, *Yogurt Caps*."[18]
The four yogurt caps, placed at eye level on each of the gallery's walls,
were ugly, ephemeral – hardly the elegant photographs and objects
that one had come to expect from Orozco: so the argument goes.
But we could ask, what did this work indicate *specifically* about the
material context of its display, much less the artist's function within
this scenario? On the contrary, one could claim that the yogurt
caps reduced to a sort of essence the lyricism of the ephemeral, the
nomadic; their near-nothingness was the poetry of the found object.

de-, dis-, ex-.

Where a critical readymade strategy, as emblemised by Duchamp's *Fountain*, reveals the mechanisms of the site of its display, Orozco's Armanesque presentation of urban detritus serendiptously found veiled the *actual* material circumstances of the gallery itself.[19] The nomad artist does not "land wherever." Moving from one commission to the next, he has a *specific* destination – a commercial or non-profit space, a Kunsthalle or a contemporary museum. Each of these destinations exists in a unique location; each has a history; each has constituencies which the institution affirms. And while lyrical nomadism in its enaction of a transient mobility through these sites implicitly acknowledges such parameters, critical nomadism exposes these conditions as the historical ground of the practice itself.

In 1986 Christian Philipp Müller led a 'garden tour' in a suburb near Düsseldorf. Among the artist's earliest works, *The Heart of the Periphery* launched what has become, for Müller, an extended reflection on historical episodes of travel and the subject who travels.[20] The proposed destination of Müller's tour, organised through the Dusseldorf civic tourist office, was the garden of an eighteenth century Grand Duke. From the very first stop, however, it became clear that this would be no ordinary tour. Instead of gathering at the garden gates, the group was asked to meet at a suburban depot. (The tour never did reach the garden.) Leading the tourists to the rear of the station, Müller recited a prepared monologue discussing the Enlightenment concepts of the Beautiful and the Picturesque, the organising principles of eighteenth century garden design. And yet a disjunction between Müller's speech and the physical reality of the setting soon became apparent. For in place of a Belvedere – the lookout of the eighteenth century chateau affording a view of the gardens below – the 'tourists' found themselves on a platform overlooking a ditch. And in place of a Panorama – the prospect of a rolling landscape beyond the garden itself – all they could see was a wall recently constructed to protect a housing development from the

noise of high-speed trains. The Panorama posited a vision of rational control exerted upon an ideal and unspoiled landscape extending into perspectival infinity; in this schema the viewer found a confirmation mirrored in nature of the anthropocentric arrangement of the garden. But the net result of this panoramic visuality was the destruction of the landscape it idealised, for as countless writers have observed, the rationalising logic of Classical garden design provided a template for modern urban and suburban development; the perceptual blockage effected by the wall pointed to this inherent contradiction.

Müller concluded his promenade with a discussion of the gazebo, the final destination of the eighteenth century garden tour. A meeting place for lovers, the gazebo is a metaphor for poetry and romance – a point suggested all the more by a string quartet playing Classical music hired for the occasion. The lyrical strains of the court composer Stamitz were difficult to hear, however, as Müller's 'tourists' found themselves standing next to a bus shelter rather than a gazebo. In this meeting of melody, speech, and traffic noise, the disjuncture of idealist notions of beauty with the banality of contemporary suburban space was revealed. As Müller suggests, the idealist fantasies of the Beautiful and the Picturesque are still integral to the logic of tourism, which capitalises on the traveller's desire to experience the poetic and pleasurable; and yet the modes of fulfilment of these needs change over time. Where tourism in the eighteenth century was an aristocratic pastime conducted at a leisurely pace, in late twentieth century capitalist society it has become a democratised if ephemeral pleasure, a momentary escape from a highly rationalised work schedule. Pursuing in travel a freedom unachievable in everyday life, the global tourist explores further and further pockets of unsullied beauty even as he contributes to an economy that propels the despoliation he seeks to escape.

For his project at the Austrian Pavilion at the 1993 Venice Biennale, Müller turned his attention from the aristocratic traveller of the eighteenth century to the unwanted immigrant of the post-colonial

Christian Philip Müller, *Eight Hikes Across the Austrian Border*, 1993.

era. His work consisted of several parts: the site-specific installation at the Austrian Pavilion, designed by Josef Hoffmann in the 1930s in a quasi-fascistic style; a series of hikes conducted by Müller across the border of present day Austria to its contingent countries, recorded by a photographer and by postcards mailed by the artist, in allusion to On Kawara, to his dealers in Cologne and New York from these frontier stations; and a series of publicity shots produced with the two other representatives of the Austrian Pavilion, the American artist Andrea Fraser and the Austrian Gerhard Rockenschwaub.[14] At Venice, Müller removed the garden wall separating the Austrian Pavilion from the symbolic 'territories' of other nations. Nearby in the conservatory, he hung picturesque engravings recording the travels of a nineteenth century Austrian illustrator through the Tyrol to Italy, the traditional pilgrimage destination for the academic artist following in the footsteps of the aristocratic tourist. In either case, Müller rendered the notion of Austrian identity porous to other nationalities. Revealing that the traditional construction of Northern artistic identity is dependent on a symmetrical construction of the Southern, Müller also reflected on the history of Biennale itself, the pre-eminent international art fair whose curatorial conception, based on the model of the nineteenth century trade fair, continues to reflect essential notions of national identity. This point was suggested all the more by Müller's amusing publicity 'appearance' in a classic Vienna café in traditional Austrian garb with the other artists. At the same time, Müller's 'hikes' across the Austrian border, initiated without visas and placing the artist at a minimal risk, pointed to the historically changing nature of Austrian identity (many of the bordering nations like the Czech Republic were once part of the Austrio-Hungary), while alluding to the very real risks immigrants face in a post-colonial, post Iron Curtain Europe, where the return of a reactionary nativist politics has had sometimes tragic effects.

The roster of historical travellers in Green's work is also extensive. There is Carl Van Vechten, the white New York intellectual whose

nightly journeys to Harlem during the 1920s are recounted in Green's undergraduate thesis; A.C. van Bokhoven, a Dutch collector whose travels around the world have concentrated on the accumulation of exotic objects *After the Ten Thousand Things*, 1994; or the American president Theodore Roosevelt, whose trophy hunts in Africa, commemorated in the zoological displays of the American Museum of Natural History, is analysed in *Vista Vision – Landscapes of Desire*. For this work, Green reconstructed a tent alluding to Roosevelt's expeditions. Inside, she installed file cabinets containing the alphabetically organised names of species 'discovered' by Roosevelt and other explorers at the turn of the century. As Green suggests, Western taxonomic practice often accompanied imperialist expansionism; the naming of species could sometimes occur in tandem with their destruction. The appendix of Roosevelt's book

> contained a list of everything that he had bagged on his safari. And the part that was incredible was that all these animals were killed and sent to museums in the United States. They were given Latin names…. Even if you don't know Latin, you can pick out names from this supposedly universal language – names of people who had been on the expedition, names of people who named the animals they killed after themselves.[21]

Renée Green, *Import/Export Funk Office*, 1992.

As Edward Said argued long ago, the traveller projects onto the place of his destination preconceived notions he has already heard or read; his view of this place and its inhabitants are mediated by these representations.[22] Where *Vista Vision – Landscapes of Desire* explores the alliances between science and imperialist politics in the travels of Teddy Roosevelt, *Import/Export Funk Office*, presented in different versions at a gallery at Cologne and at the Whitney Biennial of 1993, examined an entirely different historical episode of travel as embodied by two intellectuals who emerged in the late 1960s, the activist Angela Davis and the cultural critic Dietrich Dietrichsen. Green's analysis of two travellers of the same period allowed for a reflection on the overlapping projections of each on the other's culture; each has left home to acquire a knowledge apparently only attainable elsewhere. Where Davis, an African-American woman, travelled to Germany in the 1960s to study with the Frankfurt School philosopher Theodor Adorno, a pre-eminent mentor to the New Left, Dietrichsen made repeated visits to the United States to research black hip-hop music, a subject on which he is Germany's leading 'authority.' Green's installation reveals how the importation of foreign culture requires a translation of knowledge of the other. As Hal Foster has argued, the attempt to organise this knowledge through systematic study, and in one's own language, may entail an exoticist projection.[23] Yet the traveller's perception of his own culture is no less mediated than his view of a foreign one, Green suggests; it is near impossible to escape projecting stereotypes of the self as it is to view the other stereotypically, for as *Import/Export Funk Office* implies, these viewpoints are mutually sustaining.

In recent years Green has also thematised her own role as artist working in an increasingly global art scene. In a project for the group exhibition *Project Unité* in Firminy, France, Green was assigned an apartment, like the other participants in the show, in a housing project designed by Le Corbusier. Installing a tent that served as her sleeping quarters for the show's duration, Green created a shelter within a

de-, dis-, ex-.

shelter that alluded to the nomad artist's plight of never having a
home. To be a working producer today is to be constantly on the
move. Working conditions are hardly optimum. The artist-traveller
must work within the confines of often unfocused curatorial concepts.
She is often not paid for her work, and eats sporadically (Green
became sick with indigestion during her stay). Recording her
experiences in video and diaristic form, Green represented the Firminy
project in a second, contigent work, *Secret*, at a subsequent exhibition
in New York, creating a vectored or functional relation between the
shows that highlighted the specific character of her own
peregrinations. Presenting extensive textual documentation and
imagery pointing from one installation to the next, Green's work
explores the material and psychological factors that propel the given
traveler, and the historical and personal relations that accrue during
his or her circulations.[24] In her work, travel – and the subject who
travels – emerge as specific, historical possibilities.

An important work in this respect, and one of the salient projects
of the current nomadism, is Green's *Camino Road*.[25] Alluding to the
road novels of Jack Kerouac, the textual version of *Camino Road*,
is the story of Lyn, a recent college graduate and would-be artist
who hitchhikes to Mexico with her boyfriend Voy. But unlike *On
the Road*, which describes the narrator's cross-country travels with
excruciating and often repetitive detail, Green's brilliant re-writing of
the most iconic account of twentieth century Bohemianism represents
not an actual experience but a Beatnick fantasy of post adolescent
freedom. The reader learns almost nothing about the trip, and the
real time narrative of Kerouac is scattered into a fragmentary and
allegorical fabric of omniscient narratives, letters and dreams. The
narrator herself alludes to *On the Road*: "Do you remember – just
a week ago," Lyn writes to Von, "when I told you that I understood
Kerouac's phrase – 'everything is fine and alright forever' – I found
that phrase beautiful, even though I knew it was not true." For Green,
travel is not a phenomenologically 'pure' experience but, above all, a

desire mediated by previous figurations that predetermine the traveller's expectations and experiences. Even more, she reveals how the myth of Bohemian youth affirms the related phantasmic structures of 'true' yet transient love (Lyn and Von break up) and precocious creation: "I always wanted to be precocious. A Mozart, Picasso or Rimbaud," the narrator writes. And when it is time to 'settle down' Lyn is condemned to follow the itinerant path of Bohemia again and again. "Lyn is now living in Hoboken," the book concludes. "Before that she lived in... what was known as the International East Village, before the rents went up." (We can only surmise that she now lives in Williamsburg.) In *Camino Road*, the nomadic impulse is historicised within a longer narrative of Romantic Bohemianism. As Green suggests, this narrative is hardly new; on the contrary, it *precedes* the writer who takes it up, who parrots its conventions. "The author is always bound to a prior discourse [which] prevents him from ever making statements at will because one is always aware of what has already been written on the topic," Green writes. "By understanding the powerful hold previous texts have on what is currently said, it is possible to observe how cultural prejudices can accrue power through repetition." In *Camino Road*, Green reveals how the present-day Slacker culture as it has emerged in the realms of popular music, fashion and the fine arts, renews a prior discourse for present-day consumption. The glamorising of a casual itineracy, a devil may care irresponsibility, is revealed to be yet another of so many Bohemian returns. And in this respect Green's 'novel' is an allegory of the culture of nomadism in which artists now find themselves, a culture that valorises a return to the personal and lyrical encounter with the everyday over the discursive and critical investigations of an apparently obsolete postmodernism.

de-, dis-, ex-.

Footnotes

1 An earlier version of this essay was published in *Parkett*, 49, 1997.

2 I refer to the recent protests at the meeting of the World Trade Organisation in Seattle.

3 The establishment of the Cologne and Basel Art Fairs in the wake of Documenta (founded in the 1950s) provided an international context for the display of Minimal and Conceptual practices lacking support in the United States.

4 Other practitioners to be considered in such a discussion might include Mark Dion, Andrea Fraser, Stephen Prina, Tom Burr and Andrea Zittel.

5 On the effects of 'Slacker' sensibility in recent art see Jack Bankowsky, "Slackers," *Artforum*, November 1991. More recently, the writings around the photography of Nan Goldin and Jack Pierson reflect a similar mood. See *Boston School*, Boston: Institute of Contemporary Art, 1995.

6 Foster, Hal, ed., *The Anti-Aesthetic*, Seattle: Bay Press, 1983.

7 See, for example, Dave Hickey, *The Invisible Dragon: Four Essays on Beauty*, Los Angeles: Art Issues Press, 1993, and Olga M. Viso, Arthur C. Danto, and David Benezra, *Regarding Beauty: A View of the Late 20th Century*, Cantz, 1999.

8 Hayt, Elizabeth, "Style Directive for 2000: Make it Extravagant," *New York Times*, January 3, 2000, p. 10. "In the early 1990s, a concern for the politics of identity gave rise to a movement of angry, painful, and cynical art. And long before that, since the heyday of austere modern art, the pursuit of the beautiful was maligned as superficial.... Arthur Danto, a critic... said the world's [renewed] interest in beauty was not merely a reflection of economic prosperity, which seems to be driving fashion now. He called it primarily a reaction to the politicised art of the early 1990s."

9 On the strategic or differential relation of one practice to another within an historical field see "Painting as Model" in Yve-Alain Bois, *Painting as Model*, Cambridge, MA: The MIT Press, 1990.

10 Flood, Richard and Rochelle Steiner, "En Route: Interview with Rikrit Tiravanija," *Parkett*, 44, 1995, p. 119.

11 Bankowsky, "Slackers," p. 96.

12 Flood, Richard, and Rochelle Steiner, "En Route," *Parkett*, p. 115. For another account of this kind see Bruce Hainley, "Where Are We Going? And What Are We Doing? Rikrit Tiravanija's Art of Living," *Artforum*, February, 1996, p. 54.

13 On this notion of place, see my essay "The Functional Site," *Platzwechsel: Ursula Biemann, Tom Burr, Christian Philipp Müller*, Zürich: Zürich Kunsthalle, 1995, reprinted in *Documents*, 7, Fall 1996, and in *Springer*, December 1996-February 1997.

14 The work of Roni Horn and Felix Gonzalez-Torres, among others, imbues the Minimal object and syntax with metaphorical allusion. On this turn in 1990s art see

Lynn Zelevansky's exhibition catalogue *Sense and Sensibility,* New York, NY: Museum of Modern Art, 1994.

15 See Jean-Pierre Criqui, "Like a Rolling Stone: Gabriel Orozco," *Artforum,* April, 1996, p. 93.

16 Sans, Jerome, "Gabriel Orozco: L'Experience comme attitude," *Galeries Magazine,* January, 1994.

17 On the formal procedures of Orozco's work see Benjamin Buchloh, "Refuse and Refuge," *Gabriel Orozco,* Broel-en-Broeitoren: Kanaal Art Foundation, 1993, and "Gabriel Orozco: The Sculpture of Everyday Life," *Gabriel Orozco,* Zürich: Kunsthalle Zürich, 1996, and Laura J. Hoptman, "Options 47: Gabriel Orozco," *Gabriel Orozco,* Los Angeles, CA: Museum of Contemporary Art, 1994.

18 Criqui, "Like a Rolling Stone: Gabriel Orozco."

19 The contradictoriness of this gesture is one implicit in the readymade model itself, which posits both the lyricism and allusive critical gesture of the found object and a more explicit criticality (Institutional Critique): the distinction between the Arman accumulation and Buren's striped canvas, for example.

20 On these themes in Müller's work, explored in such recent projects as his installation in the Austrian Pavilion of the 1993 Venice Biennale, *Interpellations* (1994) and the 1995 *Tour de Suisse,* see *Andrea Fraser, Christian Philipp Müller, Gerwald Rockenschaub: Osterreichs Beitrag zur 45. Biennale von Venedig 1993,* Peter Weibel, ed., Vienna, 1993, George Baker, "Lies, Damn Lies and Statistics: The Art of Christian Philipp Müller," *Artforum,* February, 1997, p. 74, and my *What Happened to the Institutional Critique?,* New York, NY: American Fine Arts and Paula Cooper Gallery, 1993, and "The Condition of Bohemia," *Texte Zur Kunst,* May, 1995.

21 Renée Green quoted in G. Roger Denson, "A Genealogy of Desire," *Flash Art,* October, 1991, pp. 126–127.

22 See Said's classic study *Orientalism,* New York: Vintage, 1978.

23 See Hal Foster, "The Artist as Ethnographer," *The Return of the Real,* Cambridge, MA: The MIT Press, 1995.

24 Another work of this kind is Green's *Partially Buried* (1997–1998), which documents the artist's visit to her childhood home near Cleveland as well as to nearby Kent State University in Ohio, the site of Robert Smithson's destroyed *Partially Buried Woodshed* (1970). For discussions of this project, see Renée Green, "Partially Buried," *October,* 80, Spring 1997, and Brian Wallis, "Excavating the Seventies," *Art in America,* September, 1997.

25 *Camino Road,* Free Agent Media, 1994. The quotations below are from this source.

26 Green quoted in Denson, "A Genealogy of Desire," p. 127.

de-, dis-, ex-.

nais
ieus
ro

Maria Lionza

JADE

GENE

A. ARTAU

BILLANC

②

ML LEAUTAUD

ALFRED MÉTRAU
80

124

MINE

TOUSSAIN

Lothar Baumgarten: The Seen and the Unseen
Anne Rorimer

Shortly before completing his studies at the Kunstakademie in
Düsseldorf in the late 1960s, Lothar Baumgarten had begun to
reappraise the means and ends of two- and three-dimensional
representation. At this time, he was already developing strategies for
undermining the commercial aspect of art and for investing his art
with social content. By the middle of the next decade, his reappraisal
of representation had led to works that, referring beyond their
immediate architectural and temporal frame by means of language,
would expand the meaning of their site. A brief survey of his early
production and a look at several site-specific works from the 1980s
illustrates the nature of his aesthetic method.

Baumgarten's early works investigate methods for encompassing
other times, places, societies, or cultures within a representational
whole without resorting to imitative replication or static materiality.
The Pyramids (1968–1969), reflecting the artist's discontent with the
commercialism he experienced at the Cologne Art Fair in 1967,
privilege the ephemeral over the eternal and the perishable over the

portable. Variously coloured (blue, red, yellow, or white) and under one foot high, the Pyramids consist of finely powdered pigment and make the process of time visible. The first of this group of sculptures, *Tetrahedron (Pyramid)*, was cobalt blue and was installed on a concrete floor. *Pigment geschichtet (Stacked Pigment)* in red, was displayed on the ground cover of a forest. After a number of weeks, these geometric shapes made of pure pigment fall apart of their own accord. If touched, they disintegrate into a pile of dust. The Pyramids are materially non-lasting and, moreover, cannot be repositioned without being reconstructed.

At the time Baumgarten was constructing the Pyramids, he was also devising strategies by which to counter the notion of the timeless art object. His use of found objects, photography, and linguistic nomenclature made it possible for him to bring alternate realities into existence under the banner of representation. *Mosquitoes*, for example, was created from pigeon feathers inserted into small loaves of bread. Bread and feathers, looking like buzzing insects, transcend their respective identifying characteristics to form a new whole and transform the character of a room by their presence.

During the late 1960s and early 1970s, Baumgarten created many other sculptures that answer to his term 'manipulated reality.' Because of the unfeasibility of preserving them, he documented them photographically to freeze them in time. Works in this vein, which now exist only as photographs, juxtapose the artificial or man-made with the natural to create images that, (con)fusing the two, proffer another reality. In *Augapfel (Eye Ball)*, the blue ping-pong ball poised at the centre of a leafy aquatic plant floating in a pond is about the fragility of the eye ball and the intangibility of the site of vision. In *Antizipierte Gürteltiere (Anticipated Armadillos)*, a section of the profile of a rubber tyre looks like a scaly animal creeping through the wooded undergrowth. In *Verlorene Früchte (Lost Fruits)*, red shoe trees appear to have sprouted from the ground amidst growing lily leaves and grasses. In *Der Jaguar kann niemals seine Flecke verlieren*

(*The Jaguar Can Never Lose its Spots*, 1970), a solitary music stand in a swampy forest supports a close-up black-and-white photograph of spotted fur, which, positioned like a musical score, plays upon representation's capacity to invert fact and fiction within its own parameters. Appropriately, the title is based on a Brazilian saying that correlates with "you are what you are."

These works capture what the artist refers to as the "psyche of things," which resides in complex, unspoken understandings that produce a kind of 'silent enigma' arising from processes of perceptual association. Elaborating on his early works, in which objects in lieu of linguistic elements are connotatively employed, Baumgarten has suggested:

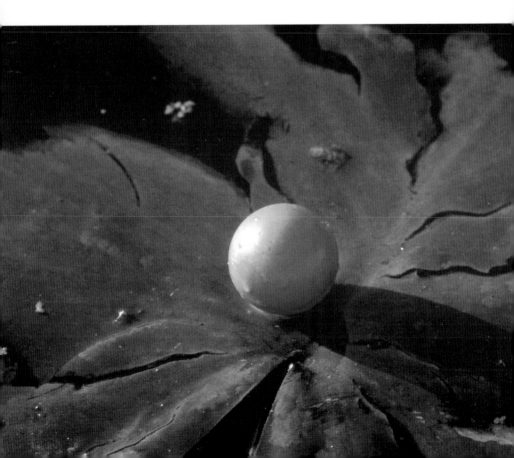

The ephemeral sculptures and the concept of their specific model characteristics became a draft for a grammar, creating an interaction between language and form. They belong to a cultural critique that is rooted in their time-limited nature and in the silent manipulation of found circumstances and things. They were mostly realised outdoors in parks, on the outskirts of the city, or in the anonymous context of the street. Things left behind in the no-man's land of present-day culture create an anthropology of place without incumbent metaphor.[1]

Linguistic elements in the form of place names found on maps and the names of indigenous groups once freely inhabiting the pre-industrial world of the Americas had entered Baumgarten's aesthetic vocabulary by 1968. North and South American tribal societies are re-membered in *Feather People (The Americas)* by means of feathers, maps, and nomenclature. The feathers are glued to a map of the two American continents, which are printed side by side on a page torn from an atlas. Names of previously reigning populations, such as the Cayapo or the Cheyenne Navaho, have been either hand-painted or rubber stamped by the artist on the feathers. The adhesion of labelled feathers to printed place names on a map anticipates the cohesion of sign and site in later works wherein architecture would replace cartography as a presentational ground and structure.

A twelve-and-a-half minute projection of eighty-one slides – entitled *Eine Reise oder 'mit der MS Remscheid auf dem Amazonas': oder der Bericht einer Reise unter den Sternen des Kühlschranks (A Voyage or 'With the MS Remscheid on the Amazon': or the Account of a Voyage Under the Stars of the Refrigerator)* – is a multi-layered meditation on travel through the channels of the imagination via photographic and linguistic representation. The projection draws upon three ethnographic accounts of South America published in the early twentieth century: *Die Sammlung Boggiani: Indianertypen aus dem Centralen Südamerika (The Boggiani Collection: Types of Indians of Central South America)* by the Italian artist Guido Boggiani and the German anthropologist Theodor Koch-Grünberg's *Zwei Jahre Unter*

den Indianern: Reise in Nordwest-Brasilien (*Two Years Among Indians: Travels in Northwest Brazil*) and the five-volume *Vom Roroima zum Orinoco: Ergebnisse einer Reise in Nord-Brasilien und Venezuela in den Jahren 1911–1913* (*From Mount Roroima to the Orinico: Results of a Journey in North Brazil and Venezuela in the Years Between 1911–1913*). Photographs taken by Baumgarten of his ephemeral pieces and the lower Rhein landscape are interspersed with texts and images from these early ethnographic sources. The title of the work refers, first of all, to the freighter that took goods back and forth between Germany and Brazil and, secondly, to works by the artist realised inside of his refrigerator. *Flora* is just one of several installations incorporating butterflies that took wing from cocoons. Stored in the icy, crystalline (and star-like) environment of the refrigerator – which, in this instance, contained a package of margarine with the brand name of 'Flora' – they came to life when the fridge door was opened to let in warm air, "flying into the room like a battery of airplanes leaving their parked positions." The image of tropical and exotically coloured butterflies put on ice and then set free resonates with the artist's involvement more generally with capturing and preserving that which is transient or vulnerable.

Die Reise... covers a vast amount of territory – from the artist's home and studio to distant lands inhabited by foreign, nomadic peoples with non-Western lifestyles and customs. The use of found objects and the introduction of unexpected, fragile materials, moreover, mirrors the ephemeral characteristics of nomadic lifestyles. Rather than being asked to stand in front of a stationary object or image, viewers are taken by way of language and photography to times and places characterised by other mindsets. Overall, *Die Reise...* looks ahead to Baumgarten's method of bringing elements of locution to bear on aspects of a work's location.

Ensuing works of the early 1970s likewise call to mind earlier, non-European cultures from within their representational and thematic boundaries. A retouched silver print, *Amazonas-Kosmos* (*Amazon-*

Cosmos, 1969–1970) delivers its pictorial message by means of language. The names given to some two dozen South American indigenous societies are printed on the surface of an image appearing to be a tropical forest landscape. By photographing a form of European broccoli at short range, Baumgarten created the semblance of a dense jungle environment. Names such as Tapirape, Xikrin, Urubu, Bororo, or Tupi, superimposed on the image of jungle vegetation, linguistically make reference to peoples whose cultures, based in nature, have been altered by Western values and practices. The name Tupamaro refers not to a society but to a left-wing guerilla group of the 1960s in Peru.

When Baumgarten laid a single, large, red wing feather from a macaw in an opened panel of parquet floor for the realisation of *Kultur-Natur: Parkett I*, he pointed to the 'unnatural' separation between nature and culture fostered by Western society. In *Kultur-Natur: Parkett II*, the bright red feather, alluding to "the invisible, animistic cosmos of non-writing cultures," lies hidden beneath unopened floorboards. Like the isolated word in a text, the feather garners meaning by virtue of its placement within a structured framework. Belonging to the plumage of a large parrot and not to the parquetry of an apartment, it seeks to ensure a permanent presence for non-Western thinking despite its near demise. Because of its vibrancy, it serves on a purely aesthetic level to rule out handmade or painted artifice as a requirement of visual representation. It further signifies the transformation of trees into parquetry patterns. Anticipatory of Baumgarten's later oeuvre, *Kultur-Nature: Parkett I* and *II* create a dialectic between imported symbol and existing architecture.

Feathers used by Baumgarten in *The Origin of Table Manners*, whose title is taken from the well-known anthropological text by Claude Lévi-Strauss, played a signifying role within an unorthodox contextual situation during his 1973 exhibition at the Sperone Gallery, Rome. A limited edition packaged in a box, the multiple consists of a table setting with dinner plate, soup bowl, and napkin as well as two

arara feathers and two porcupine quills instead of silverware. The Sperone exhibition was held in a restaurant where the artist laid a table for four with the plates, feathers, and quills. Within the 'setting' of the Roman restaurant, the feathers and quills were 'out of place,' but within the site-specific context of art, they made a place for themselves.

Contained within a box lined with lizard-skin book-binding paper, fifty eagle feathers comprise *Section 125–25 64–68: Hommage à m.b.*, a collaboration between Baumgarten and the anthropologist Michael Oppitz. Except for one feather (left blank as a catch-all for any group not specifically mentioned), each has been painted in freehand with the name of a North American native society such as Arapaho, Blackfoot, or Delaware. Information and bibliographical material pertaining to the numerous uses of feathers by indigenous peoples is also provided along with five assorted texts (by the artist and other authors) related to the eagle and five anthropological photographs. The numbers in the work's title are geographical co-ordinates for North America.

Lothar Baumgarten, *Amazon Cosmos*, 1969–1970.

Section 125–25 64–68: Hommage à M.B. metaphorically plucks the feathers from the eagle in order to scrutinise its many pre-industrial applications. As free-floating signs, the labelled feathers (which Baumgarten had begun to collect many years before) allude to the numerous dispossessed populations of North America. When unpacked for exhibition purposes, they may be laid out in a vitrine in a geographical ordering or pinned to a wall in a configuration suggesting the shape of the continent. The auxiliary information about the eagle, left in the box, remains in full view for consultation. A transportable work that travels from one site to another, it refers not only to the emblematic eagle of Broodthaers' Düsseldorf exhibition but also to the cultures, eclipsed by modernity, where the eagle had a range of real applications and functions in everyday life, from the medical to the spiritual.[2]

Tropenhaus represented Baumgarten's participation in the exhibition 'Kunst bleibt Kunst' at the Cologne Kunsthalle in 1974 and was realised within the context of an architectural site – in this case, in the large glass conservatory in the grounds of Cologne's botanical garden. Occurring within a greenhouse where tropical trees and vegetation were on public view, Baumgarten's work supplemented the conservatory's perfunctory labelling system with some five hundred citations, all of which were related to the regions where the plants originated. He used green plastic labels identical in size and typeface to those already in use (which were hand-lettered by one of the botanists on staff), but greatly expanded upon the existing didactic information, which merely supplied the Latin name of each plant.[3]

Baumgarten's extensively researched texts varied in length from a word to a paragraph. Larger, one-word labels presented the names of native peoples such as the Caduveo, Xamacoco, Bororo, Yanomami, Nambiquara, Shipibo, Parintintin, Waura, or Tirijo on the one hand and, on the other, the names of explorers, chroniclers, conquistadors, geographers, ethnographers, merchant travellers, etc. who, over the last five centuries, have left their mark on the body of knowledge about

the tropics. These included names such as Humboldt, Nimuendajú, J. de Léry, F. de Orellana, L. de Aguirre, Sir W. Raleigh, A. de Berrio, and H. Staden (the title of whose sixteenth century account of Brazil is part of the complete, much longer title of *Tropenhaus*). Small labels provided the names of principal South American rivers – the Tapajoz, Rio Negro, Orinoco, Amazonas, Xingu, Uaupés, Tocantins, and others. Taken as a whole, Baumgarten's texts opened up new horizons against which to consider the transplanted tropical specimens. Animal names like 'ant-eater' or 'tapir'; phrases like "in between times" or "land of the mute dogs," observations like "occasionally the intoxicating smell of invisible blossoms fills the air" or "the world's tropical rainforests are the most impressive sites of biological diversity" filled the greenhouse with a mind-expanding amalgamation of quotes and excerpts from a broad selection of writings and from the myths and stories handed down by societies without written language. Dispersing the labels throughout the tropical greenery, Baumgarten staked some of them in the ground among the pre-existing labels, and strung others between plants. Yet others were suspended from branches, lodged in the forks of trees, or attached to tree trunks. Without disrupting the greenhouse display and nearly camouflaged within it, *Tropenhaus* freed the plants from exclusive classification in the dead, European language of Latin. Baumgarten's labels animated the artificial hothouse atmosphere, where "an entire cosmos only exists when the heat is turned on and an artificial rain falls twice a day" through the unobtrusive yet ubiquitous presence of informational and associative language.[4] Proper names, adjectives, and descriptive passages interpenetrated the vegetation and connected the transplanted tropical growth with its former climatic, historical, cultural, and/or socio-economic conditions. By means of language, *Tropenhaus* imported otherwise unapprehended aspects of a larger geographical totality into an architectural framework that had previously "excluded the voices of the rainforest through the silent presence of an imposed scientific order" based on Western systems

de-, dis-, ex-.

of thought and nomenclature. The work, in this way, established alternative points of reference and evoked past or perishing landscapes and cultures.

Three later works – *America, Les Animaux de la Pleine Lune: Une Cosmographie de la Touraine*, and *The Tongue of the Cherokee* – further illustrate how Baumgarten gives new signification to an exhibition context by means of language. As in the case of *Tropenhaus*, contingent circumstances determine the content of the work. In these later works, however, linguistic elements directly intervene into the actual architectural structure to visibly reconstrue and metaphorically reconstruct the architectural environment in question.

Conceived for the German Pavilion of the 1984 Venice Biennale, *America* (representing the topography of the Amazon Basin) was inlaid in, and made flush with, the sandy-grey marble floor of the exhibition area. Visitors could walk over and around dark reddish-brown names of the seven major rivers of the Amazon-Orinoco river system (the *Amazonas, Tapajos, Xingu, Purus, Orinoco, Vaupes*, and *Tocantins*). The centrally positioned word 'America' comprising black letters placed against a proportionately scaled white background was likewise set into the floor. Four large geometric pictographs, representing a jaguar, eagle, cayman, and turtle, which are indigenous to Venezuela, accompanied the names of the rivers.

For the design and conception of *America*, the artist drew a number of parallels between Venezuela, which Amerigo Vespucci had named 'little Venice' in 1499, and the city of Venice. Having discovered houses supported by poles in the water, he also noted the similarity between the distribution of the rivers of the Amazon Basin and the Venetian waterways in aerial views and remarked on the necessity for travelling on foot or by boat in both Venice and the Amazon forests. Other factors also came into play. The schematic patterns formed by the 'tombini' (incisions in the pavement for drainage), observed underfoot throughout Venice, inspired his placement of the stylised

animal symbols on the floor. The far reaching historical connections between the Italian portal city and the South American continent thus effected, as articulated by Craig Owens, a "nonviolent model of cultural confrontation in which one culture can occupy the space of another without obliterating it."[5] The river names and animal abstractions thereby sought symbolically to put Western and non-Western cultures on an equal footing.

Les Animaux de la Pleine Lune: Une Cosmographie de la Touraine, installed for a group exhibition in the Château d'Oiron in France near the region of the Loire, once again allied architecture and language. With the intent of recreating the literal and historical climate of the period of the sixteenth century château, Baumgarten adhered approximately one hundred proper names, words, and phrases from François Rabelais's social and political satire *Gargantua and Pantagruel* of 1552 to the walls of one of its salons. Using black, red, white, blue, and yellow paper (of the kind for covering over billboard advertisements) and wooden printer's blocks with Grotesque typeface, Baumgarten covered the walls of the room with words and phrases, which were scaled according to their relative importance in Rabelais's book. In this way, he produced a multi-layered coating of verbal and visual meaning, which he formally enhanced by large black paper rectangles that provided a modulating background structure. The colours of the strips of paper supporting the printed words repeated the colours of the room's overhead beams on the one hand, and, on the other, coincided with the primary colours used by early modernist artists such as Piet Mondrian. At the same time, language mediated between the work's content and its context inasmuch as isolated words and individual phrases referred to Rabelais' characters, to plant and animals of the area, to recipes from the regional cuisine, and to the nature of life and society in the sixteenth century. In brief, Baumgarten – who also restored the floor of the room to its original state and burnt odorous ash logs in the fireplace – revivified the long-abandoned chamber of the château. Through the fusion of abstract

and semantic elements, he connected the work with the geographical and cultural setting of the exhibition space while attempting to capture the sense of Rabelais' language and the radical implications of his writings.

Permanently installed in The Carnegie Museum of Art, Pittsburgh, *The Tongue of the Cherokee* imbues its physical site with shifting visual readings while it expands the cultural dimensions of the institution that houses it. In lieu of creating a work for the walls of the museum, Baumgarten utilised the glass ceiling of its impressively proportioned Hall of Sculpture. Here, through a process of sandblasting, lamination, and painting, the eighty-five syllables comprising the syllabary of the Cherokee Nation were individually distributed among and inscribed upon the glass panels of the ceiling's expansive grid.

Lothar Baumgarten, *Les Animaux de la Pleine Lune: Une Cosmographie de la Touraine*, 1986–1987.

The Hall of Sculpture – along with the adjoining Hall of Architecture where plaster casts of historic monuments are on display – was added to the original museum building of 1895 when its exhibition area and facilities were expanded a decade later. Founded by the industrialist and philanthropist Andrew Carnegie of the Carnegie Steel Company, the museum was conceived as "An American Palace of Culture," whose library, music hall, natural history museum and art museum are brought together under one roof.[6] Although The Hall of Sculpture, which opened in 1907, is located in the Natural History Museum, it is directly linked with the Museum of Art by a connecting foyer. Functioning mainly as a thoroughfare between the Museum of Art and the Natural History Museum and as a space for holding performances and other public events, the sculpture hall was constructed specifically to exhibit the collection of plaster casts of antique statuary acquired by the museum at the end of the century. The inner court of the room measures about 100 feet in length and is more than twice as long as it is wide. Surrounded by Ionic columns on ground level and by Doric columns on the second story, it is an academic exercise of Classical motifs and architectural details. The architects of the Hall chose to use the white, Pentelic marble of the Parthenon in Athens in order to evoke the cella of the famous Greek temple. Significantly, a plaster reproduction of the Panathenaic frieze from the exterior of the Parthenon encircles the entire court above the cornice line beneath the glass panelled grid of the ceiling.

Eight plaster sculptures of Amazons and Greek gods and goddesses including Apollo, Artemis, Athena, and Venus from the collection of casts still remain on view in the Hall of Sculpture. Replicating well-known Roman statues found in museums such as the Louvre or the Vatican that were copied from famous Greek originals, they stand symmetrically opposite each other on the volumetric plinths inserted between the scrolled acanthus balustrade that rings the entire second storey level of the sculpture court. The statues dramatically punctuate the space of the room and accentuate the practice of American

de-, dis-, ex-.

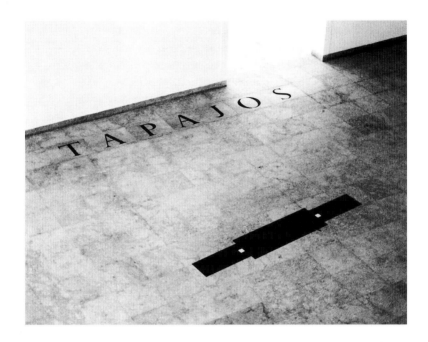

museums at the turn of the century – following earlier European examples – to define culture in terms of Greek Antiquity. The Hall of Sculpture thus signifies the way in which interpretations of, or remnants from, the Classical past, thought to be synonymous with the notion of civilisation, were transported to and transplanted in the New World as an antidote to its growing industrialisation. The words of Carnegie in a letter to the trustees of the Institute attest to the desire to counteract the effects of industry with the affects of culture.

> Not only our own country, but the civilised world will take note of the fact that our Dear Old Smoky Pittsburgh, no longer content to be celebrated only as one of the chief manufacturing centres, has entered upon the path to higher things....[7]

Lothar Baumgarten, *America*, 1983–1984.

Baumgarten's insertion of the Cherokee alphabet into the skylight of the Hall of Sculpture introduces an unexpected and – ironically enough – foreign element into the architectural conceit of a space devoted to extolling the Classical tradition. The accompanying wall label for *The Tongue of the Cherokee*, supplying relatively unknown background reading regarding the origin of the alphabet, reinforces the rationale for its addition to the all-encompassing Greco-Roman environment. The label text, written by the artist, details the history of the alphabet, which was invented by Sequoyah in the early nineteenth century. Inspired by the desire to give his people the power of writing, of which he had become aware through knowledge of the white man's 'talking leaf,' or newspapers, Sequoyah single-handedly created the Cherokee alphabet over a twelve-year period. At first he endeavoured to connect Indian pictographs with words, but subsequently studied the sounds of his language to evolve a sign system for correlating spoken syllables with written symbols. The resulting alphabet resembles the English alphabet in some respects insofar as Sequoyah borrowed a certain number of shapes from its letters and punctuation marks.

From Baumgarten's wall text one learns of the fate of the Cherokees, who by 1827 had decided to print a national newspaper, the *Cherokee Phoenix*, in their own language as well as to form a political structure modelled on that of the United States as a means to unite their dispersed villages. However, as Baumgarten explains, the Cherokees' newfound statehood and ownership of their land was abrogated by the North American government upon deportation of their entire nation to the state of Oklahoma. Sequoyah, nonetheless, is remembered for his genius in teaching his people to read and write and for being, as the label points out, "the only one in history to develop an alphabet or syllabary completely on his own."

On a formal and structural level, Baumgarten's Pittsburgh work takes advantage of the tripartite sub-divisions of the ceiling grid consisting of 189 individual glass panels. These belong to twenty-one

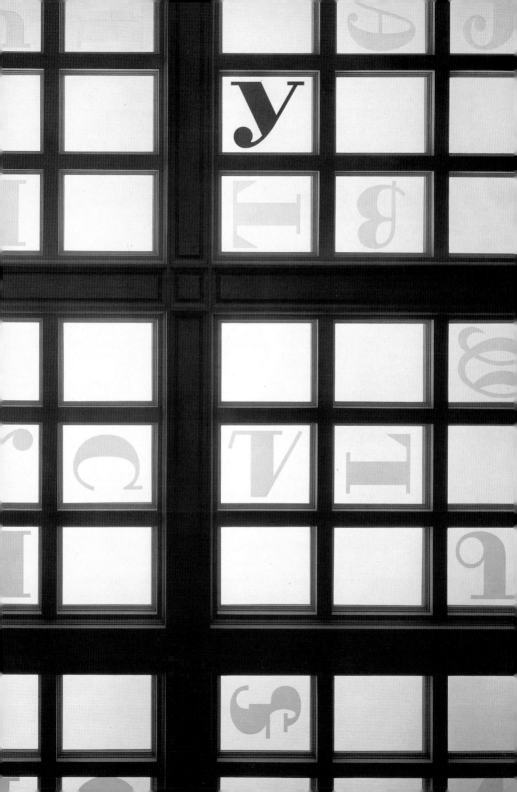

larger sections, each of which is broken down into nine, nearly square, rectangles of glass (aligned in seven rows of three sections across). The letters of the Cherokee alphabet, separately assigned to their own panes of glass, have been sequentially laid out by Baumgarten – and succesively turned 45 degrees – in boustrophedon manner up and down from one set of nine glass panels to the next, beginning at the Northwest corner of the ceiling and ending up in the Southeast square of the overhead grid. Each group of nine rectangles possesses four letters apiece (except for one that has five), which have been differently distributed within each of the nine-square groupings and, within these separate sections, may be followed alphabetically in clockwise fashion. The overall arrangement of the letters and their varied positions in relation to the empty panes of glass avoids the rigidity of a dogmatic system as well as a hierarchical compositional ordering. Proportionate with their designated glass rectangles, the shapes of the letters produce a lively interchange between one another inside of the regulating structure of the ceiling grid.

Positioned directly above the reproduction of the Parthenon frieze, *The Tongue of the Cherokee* reflects on its context within an environment that aspires to imitate Classical antiquity and on its location in Pittsburgh, steel capital of the modern world. By thus paying tribute to an important but disregarded figure in American history, it calls attention to cultural and historical omission. In an attempt at rectification, the skylit work initiates a confrontation between the imported culture of Europe and the once dominant cultures of indigenous peoples of the United States. The separate letters of the alphabet, moreover, function simultaneously as representational sign and abstract figuration. They offer a diversity of forms whose variety relies on the reality of already existing figuration rather than on the arbitrariness of personal invention. The letter forms give the impression of being self-sufficient objects inasmuch as they are seemingly suspended against the sky rather than depicted against a solid, two-dimensional surface. Five brightly coloured, royal blue

de-, dis-, ex-.

letters are placed intermittently throughout the ceiling, highlighting the warm grey colour of the majority of letters. The colouring of the letters, as well, changes continuously throughout the day from white to creamy beige to grey in differing relationships to each other. Controlled by the movement of the sun in combination with the shifting cloud cover, the colour of any one letter is never fixed and the ceiling imagery is therefore never static. If the Carnegie's Hall of Sculpture provides the immediate and literal support for *The Tongue of the Cherokee*, the sky above it functions as the 'ground' for a work that fosters an interchange between Classical Greek and Native American forms and between architecture and language.

The work of Lothar Baumgarten fulfills the artist's "desire to anchor an aesthetic dialectical praxis in the social and political conditions" of the present by "making an analytical effort to free the historically and socially based reality from the imposed myths cloaking it."[8] Baumgarten achieves this goal through the cohesion of architecture and language at the point where linguistic sign systems are conjoined with an existing site so that each given space might be understood from alternative historical and cultural points of view within an overall social perspective. Because of their capacity to perform at once as abstract configuration and cultural symbol, linguistic elements serve both formally and representationally in Baumgarten's aesthetic production to link the visible, material aspects of the work with those invisible factors that contribute to seeing the larger picture. Using letters, words or texts as a window onto intangible but forcible realities, he avoids the creation of free-floating, commercially viable objects that do not critically evince their own situation within contemporary Western culture.

Footnotes

1 This and all following quotes not otherwise identified are from the author's unpublished interview with the artist, December 1999.

2 Baumgarten, Lothar and M. Oppitz, *T'E-NE-T'E: Eine mythologische Vorführung* (Düsseldorf: Konrad Fischer Gallery, 1974) details how the eagle feather has actually been used by different North American societies.

3 Baumgarten developed this work into *Die Namen der Bäume*, which functioned in place of and *as* an exhibition in 1982 at the Stedelijk Van Abbemuseum, Eindhoven. For the full title of *Tropenhaus*, which includes reference to *Zwei Reisen nach Brasilien 1548–1549 und 1550–1555* by the sixteenth century muscateer Hans Staden, see p. 380, no. 55.

4 Baumgarten, Lothar, in conversation with the author, June 1989.

5 Owens, Craig, "Improper Names," *Art in America,* October 1986, p. 129.

6 See John R. Lane, "A History of the Collection," in *Museum of Art, Carnegie Institute,* Pittsburgh: Carnegie Institute, 1985; and James D. Van Trump, *An American Palace of Culture*, Pittsburgh: Carnegie Institute, 1970.

7 Andrew Carnegie, quoted in Joseph Frazier Wall, *Andrew Carnegie,* Pittsburgh: University of Pittsburgh Press, 1989, p. 817.

8 Baumgarten, Lothar, "Status quo," *Artforum,* March, 1988, p. 108.

de-, dis-, ex-.

CHIEN ANDALOU

LE
~~RAUL~~

OURT
ARROZ CON L
MARCEL S
GUILL
PO

③ ——— ④

3.

L'OUVERTURE
(L'OUVERTURE)

TUPAC AMA
TUPA-MA

EN A

ANDALOU

LESUEU

~~PAUL~~ ~~LE~~

con Leche

CEL SEMB

GUILLAUME

PORTE

URT

RROZ

MARC

④

3

3

L'OUV

LO7

UPA

RTURE

VERTURE

AMARU

TUPA-MARO

UR
~~AUTAUD~~

BAT BOUGAINVILLÉA
RAYNAL

GIAMBATTIST
VI

ALFRED

~~LES~~ PL

AVENUE LE

E DE SAINT-CLOUD

EXELMANS

MICHEL-AN

FRANS

MU

⑤ ⑥ ⑦

5 6

⑩ GARE D'AUSTERLITZ ⑩ BOUL

OUAHRAN IMAGO MUND

An Ethnographer in the Field
James Clifford Interview

Alex Coles Three main factors have made your work vital to debates around art over the last decade and a half. First is your critique of the Primitivism exhibition at MoMA published in *Art in America*. Second is your interest in the activities of dissident Surrealists such as Bataille and Leiris (and perhaps Benjamin too); and third is the way you foreground methods of textuality in the book you co-edited, *Writing Culture*. In many ways, your writing in the early 1980s prompted the fascination with ethnography in art practice and criticism (firstly by Craig Owens and Hal Foster, and more recently by, amongst others, Renée Green and Fred Wilson), in others it draws on it. So, with particular emphasis on the way your work has driven much of the exchange, what do you think of the traffic between art and ethnography? Do you think that it has benefited both sides?

James Clifford First I'd like to just add one name to your list of quasi-surrealists who inspired me: William Carlos Williams. He was an early, and continuous, influence – a modernist writer who made the

Michel Leiris. Photo: Christian Gauffre.

choice, against Europe's pull on his generation, for America. And not for New York City, either. For an obscure place, Rutherford New Jersey, and for the peculiarly intimate/distant ethnographic perspective and habitus of a family doctor. The poetic documentary and social critique, mixed with populism, and a visionary streak (vision at ground-level, among real people, their voices and ethnic, gendered, quirky bodies)... all this was of great significance for me for an opening up of what would become an expansive notion of the 'ethnographic.' Williams' *Paterson* became a model, a provocation for a new kind of realism. This was a situated knowledge, freed from the constraints of scientific objectivity and the Lukácsian 'type,' a path through even the most particular and subjective facts to a kind of general view, a 'big enough' vision.

Contact Zone: The Parking Lot at Palenque.
Photo: James Clifford.

It was, perhaps, just the right kind of localism (Williams was, of course, very much in touch with the modernist 'centres,' Paris and New York) for someone like me in the 1960s and 1970s beginning to feel he was no longer at the progressive centre of the world and looking for ways to be off centre, but connected. I think this wavering, this fragmenting, of the spatio-temporal centrality of modernism and of 'the West' in the 60s (the greater 60s, one might say, following Jameson) has a lot to do with the appeal of 'ethnographic' dispositions across a wide range of activities. *Writing Culture*, and the writings from the late 1970s and 1980s which were stuck together in *The Predicament of Culture*, were part of a proliferating style.

I was surprised at first by how quickly those two works were taken up by artists, writers, performance and media people. And I can only situate this influence with reference to a moment in the modernist centres and their satellites when Williams' dicta "no ideas but in things" and "the universal through the particular" took on new kinds of meaning. People no longer saw themselves making 'art' or contributing to a cumulative 'culture.' Art and Culture seemed like local acts now, provincial definitions (an 'art-culture system,' I called it). And the response wasn't to rush to some new, emergent, historical centre of avant-garde activity. The world seemed to secrete many, divergent arts and cultures, discrepant modernities. One's task as an 'ethnographer' (defined, predominantly, as cultural critic, a defamiliariser and juxtaposer) was to mine the museum, in Fred Wilson's terms, to probe the cracks, search for the emergent: Benjamin's messianic time, without any particular messiah.

I think we can see, now, this was a response to decentering, and perhaps a preliminary millennialism, by people in a historically displaced condition. Not a universal prescription or normative 'postmodernity.' To be sure, the ethnographic disposition partook of a certain privilege, a luxury to explore one's own coming apart, to work with fragments. But I think it would be wrong to reduce

this set of critical and quasi-documentary attitudes to a negative stereotype of 'postmodern' relativity and self-absorption. For those representing marginal, or populist, modes of life and expression it offered a place, albeit circumscribed, in the wider, public debates. And for those coming from sites of relative privilege there was, and is, a genuine openness to a broader world of popular and non-Western possibilities and agencies here. I would like to think that, at its best, the 'ethnography' which emerged across many fields in the 1980s rejects quick and dirty symptomatic analyses. It reflects a willingness to look at common sense, everyday practices – with extended, critical and self-critical attention, with a curiosity about particularity and a willingness to be decentred in acts of translation.

One thing that you have been brought to task for, at times by those same art critics (particularly Hal Foster in "The Artist As Ethnographer") is the way you loosen up the notion of what an ethnography can be. In other words, you re-define the parameters of what constitutes field work, participant/observation, etc. But are the methodologies of ethnography infinitely expandable? Or do they snap when pushed too far?

Of course all methodologies, which in interpretive/historical studies are always modes of partial translation, first get you somewhere and then run out of gas. 'Ethnography,' whether in its strict anthropological or expanded cultural-critical sense, is no exception: it involves recognition and mis-recognition. Hal Foster, reacting against its sometimes uncritical popularity in art practices of the early 1990s, cuts 'ethnography' down to size. And in this he's part of a necessary counter-trend. (There have been regular flare-ups, too, in a border war between anthropology and cultural studies over what counts as real ethnography.) But I would caution readers of Hal's several pages (in *The Return of the Real*) on 'the new anthropology' that he provides a very truncated account. His direct references to the movement under

discussion are limited to a couple of my essays from the early 1980s.
And in a common dismissive move, the new anthropology is reduced
to textualism and hyper reflexivity. This freezes a particular moment
of what has been a complex, ongoing critique and decentering of
cultural representations and relations of power. There's so much more
to the ferment in socio-cultural anthropology during the 80s than a
(selective) reading of *The Predicament Of Culture* can register!

Even that book's most 'textualist,' and often-cited, chapter;
"On Ethnographic Authority," is a critique of the modes of critical
authority Hal properly questions. To see it as reducing everything
to text or – a rather different thing – to discourse, slides over the
essay's central proposal that anthropology's former 'informants' be
thought of as 'writers.' This proposal argues that the space of cultural
representations is populated by differently situated authorities,
producers, not simply conduits, of self-reflexive 'cultural' knowledge.
For there is no longer a standpoint from which one can claim to

definitively administer, or orchestrate, the textualisation of 'identity,' 'tradition,' or 'history.' A heteroglot, overlapping and contested public culture – including indigenous writers, readers, and performers – characterises the post-/neo-colonial context which the self-critical work of the late 1970s was beginning to reflect in Western academic contexts. By the late 1980s it was inescapable that anthropological fieldwork would never again be a matter of an outsider scholar interrogating insider natives and emerging with neutral, authoritative knowledge. The 'textual' critique of older, classic ethnographies showed that there had always been more going on: more negotiation, translation, appropriation. But now the politics and the poetics were in the open – not only because of the new theoretical self reflexivity, poststructural concepts of textual indeterminacy and dialogism, but more profoundly because of pressures from decolonisation and feminism.

The chapter in *The Predicament of Culture* on Marcel Griaule was centrally focused on the colonial context, seen from the post-war perspective of its contestation, and emphasising the issue of African agency in a negotiated ethnographic co-production spanning four decades. The book's later sections critiquing modernist primitivism, and the history of collections, were equally focused on bringing into view the socially and politically fraught nature of cross-cultural representations. And so expanding the range of activities qualified as ethnographic, or as art/culture-collecting, was an attempt to decentre canonical Western styles. And if this was all done from within a changing 'West,' and with theoretical tools of self-critique, it was done with an ear out for non-Western, and partially-Western, voices.

Routes, a 1990s book, assumes this mix of location and receptivity, tracking the conjoined practices of travel and translation. It assumes that while one's geo-political, worldly itineraries and encounters are powerfully constrained they are not ultimately determined. Location isn't a prison; it's comprised of material, but unfinished, maps and histories. In this book the ethnographic trope is replaced by a 'travel'

metaphor – similarly a source of insight and blindness, a translation term that needs to be cut down to size. Displacement, forced and voluntary, exists in an always-unresolved dialectic with different forms of dwelling, of staying put. Clearly this all has to do with the phenomena too hastily gathered under the rubric of 'globalisation,' a matter of transnational flows, the making and remaking of cultures and places. *Routes* argues against closures in our struggle to understand the present historically. The structuring context of 'late capitalism' troubles (but does not erase) the context of decolonisation that organised *The Predicament of Culture*. *Routes* tries to inhabit a tension, an antinomy, of neo- and post-colonial narratives.

In recent years there has been a resurgence of interest in artists that developed an ethnographic understanding of site in their practices in the late 1960s (particularly Robert Smithson and Lothar Baumgarten). Today the notion of the 'ethnographic site' is being further expanded by a number of artists. This is interesting given that a grasp of site-specificity has always been crucial for ethnographic field-work and textual ethnographies. Indeed, in "On Ethnographic Surrealism" you attest to the fact that "exploration of ethnographic activity" must always be set in "specific cultural and historical circumstances." Is this an ethnographic definition of site-specificity?

It's interesting to connect an 'ethnographic' approach with 'site-specificity' in art. Both are ways of decentering established centres of art/cultural production and display, and so I would be tempted to locate them in the general context I've just outlined. But it's important to recognise that turns to the specific and the local occur in contexts of 'complex connectivity,' to adopt John Tomlinson's substitute for the diffusionist term 'globalisation.' (*Globalisation and Culture*, 1999). I'd always want to stress, as in the case of *Paterson*, the entanglement of the particular, not with Williams' modernist 'universal,' but with networks of power and communication. If this means we can no

longer speak of the 'merely' local, then we need to interrogate the performative specificity of any ethnographic or site-specific production. Such productions make sense only given audience access (physical access, or written, photographic representations). People have to know, somehow, about *Spiral Jetty*, or Lothar Baumgarten placing the names of Indian groups in a Caracas botanical garden, or Ana Mendieta burning her body outline on the earth. Nowadays a video camera is an integral part of any site-specific, or local, performance, whether it's Guillermo Gomez-Peña and Coco Fusco infiltrating major museums as caged New World 'savages' or the opening of a tribal museum in Alaska. The same goes for any ethnographic work, always already caught up in modes of representation and reception. I suppose that's still *Writing Culture*'s message: we are talking about concrete, relational, articulations of 'specificity.'

You suggest that something similar applies to temporal contextualisations. The cultural and historical circumstances of 'ethnographic surrealism' were, I argued, a Europe putting itself together after a war of unprecedented scale and brutality, and a modernism whose access to the non-Western 'primitive' was going through quantitative and qualitative shifts. Ethnographic surrealism

Ethnographic Surrealism on the Street: Palenque. Photo: James Clifford.

named a critical formation which made sense in this conjuncture –
not an avant-garde method or a precursor of postmodernism. But
by recognising and naming it, I was positioning myself and my
readers in the culturally decentred, corrosively self-critical, post-60s.
Specificity, whether of site or historical moment, is always relative
to its representations. A local formation, or a temporal conjuncture,
is part of some larger projection of relevance or meaningfulness
which makes sense in 'contact relations' which are never transparent
or free of appropriation. This is the basic performativity which an
ethnographic poetics and politics assumes.

**In your writing you often take the ethnographer (and the discourse
of anthropology) as your primary site. A neat quote from Paul
Rabinow attests to this, "Clifford takes as his natives, as well as
his informants, anthropologists." (You even quoted this passage
in *The Predicament of Culture*.) What do you think of this?
Is it less true now than it was a decade ago?**

Well, my relations to anthropologists, whom I have never considered
to be 'my natives,' have been complex. A kind of fraught, shifting
colleagueship would be more like it. Paul's quip was meant to say
that I couldn't, as a critic, escape the structures of authority I analysed
in anthropological fieldwork. To which I responded, by making his
text an epigraph: "of course." Nor were the predicaments I thought
I could see with special clarity in a changing anthropology peculiar
to one discipline. But socio-cultural anthropology – perhaps because
of a certain historical exposure, because it was so inescapably located
in changing (decolonising, recolonising, modernising, re-localising
etc.) cross-cultural domains – lived through crucial problems of
authority in a very public way. And anthropology's experience, its
'crisis,' became a paradigm for other fields where similar pressures
were being felt.

I think that anthropology has grappled with the historical changes

in its relations with its 'objects' of study in a generally positive way. The process has not led, as some feared, to self-absorption and hyper-relativism, but to much more complex historical accounts of an expanded range of socio-cultural phenomena. As I've already suggested, the occasions of ethnography have come to be articulated in ways that necessarily include discrepant and ongoing processes of cultural representation and reception. Given these developments in socio-cultural anthropology, I find myself now more a participant than an observer. I particularly value the textured perspectives from geo-political 'peripheries' and 'marginal' places that anthropological ethnography still delivers. The discipline offers a critical corrective to global-systemic projections of the planet and its future. I'm always astonished and chagrined to find how little ethnography and ethnographic history people in the academy and art world at large actually know. (Some read me – or Johannes Fabian's *Time and the Other*, but never his many ethnographies – and think that's all they need.) I keep running into sophisticated scholars, artists, and intellectuals who still assume that the spread of McDonalds in many world cities, or the arrival of English, Coke, country music, anthropology and tourists in places like New Guinea results somehow automatically in a wholesale destruction of local affiliations, a homogenised world culture. Cross-cutting agencies, and the contradictions of everyday life, just disappear. Such a partial, Eurocentric view, and so satisfyingly tragic!

In your most recent book, *Routes*, you develop the idea that a site is not necessarily defined by fixed spatial and temporal boundaries. Specifically, you suggest that a site can be a 'contact-zone'; i.e. a place located *between* fixed points, one that is constantly mobile. How did you arrive at this expanded definition?

Contact zone is, of course, derived from Mary Louise Pratt's *Imperial*

Eyes. She adapts the term from sociolinguistics, the notion of 'contact languages' (pidgins and creoles which emerge in specific historical conjunctures) as well as from the work of Fernando Ortiz on 'transculturation.' These are perspectives that do not see 'culture contact' as one form progressively, sometimes violently, replacing another. They focus on relational ensembles sustained through processes of cultural borrowing, appropriation, and translation – multidirectional processes. And if the productions of modernity are exchanges, in this perspective, they are never free exchanges: the work of transculturation is aligned by structural relations of dominance and resistance, by colonial, national, class, and racial hierarchies. Nonetheless, a 'contact zone' can never be reduced to cultural dominance or (more positively) education, acculturation, progress, etc. The concept deflects teleologies. In *Routes* I found it useful to think of museums (and a wide range of heritage, cultural performance sites) as contact zones because it opened them up to contestation and collaborative activity. It helped make visible the different agendas – aesthetic, historical, and political – that diverse 'publics' bring to contexts of display. The sometimes fraught politics of representation that now trouble museums, particularly those which feature non-Western, tribal, and minority cultures, appeared as part of a long, always unfinished, history. Museums as we know them were integral to the expansive 'West,' its imperial and national projects. The wholesale movement of exotic collections into 'artistic' and 'cultural' centres, involved appropriations and translations now being re-inflected, and even, to a degree, reversed. In a contact perspective, which complicates zero-sum relation between 'tradition' and 'modernity,' museums become way stations rather than final destinations.

This is quite different to the way you discussed museums in the 1980s. Can you flesh out this development in your thinking a little more?

Great Hall of the University of British Colombia Museum of Anthropology, Vancouver. Photo by W. McLennan, courtesy of the Museum.

In *The Predicament of Culture* I was primarily concerned with
a critique of Western institutions. This took two general forms:
1) questioning modes of authority both in academic ethnography
and in art world contexts such as the Museum of Modern
Art's provocative exhibit, "'Primitivism' in 20th Century Art";
2) looking for counter-discourses such as the 'ethnographic surrealist'
work of Michel Leiris, or the Caribbean surrealism of Aimé Césaire.
The book tried to destabilise Western traditions and discourses from
within – though the decolonising pressures it registered (from without)
had already undermined this location and, indeed, any permanent
inside/outside border. The career of Césaire, passing through Paris,
in and out of the West, makes this clear.

And I worked to deepen the shift of perspective that was latent in
the book's last chapter devoted to the Mashpee Indians' inconclusive
'tribal identity' trial. There I had confronted an ongoing New England
contact history and a native reality that constantly escaped
anthropological 'culture' and continuous 'history,' categories that
formed my common sense. Moreover, there was nothing radically
nomadic, deterritorialised, or rootless about the Indians who persisted

Susan Hiller, *After the Freud Museum*, 1994,
detail. Photo courtesy of Bookworks.

in and around this Cape Cod town. I wasn't portraying 'postmodern' prototypes. I was trying to bring my primary audience – enlightened, Western-educated sceptics like me – to a realisation that we were missing something: a reality of Native American existence that our received notions of culture and history couldn't grasp. The trial made me a lot more sensitive to indigenous movements with their complex rearticulations of tradition and history. One of the first things I published after *The Predicament of Culture* was an essay comparing four northwest coast museums in Vancouver. Two of these were 'tribal' museums/cultural centres. The essay, reprinted in *Routes*, marked a crucial discovery for me. I began to see the museum, that most stodgy and Eurocentric of institutions, as a dynamic, disseminating institution which could take a diversity of forms in particular local/global conjunctures. Of course the critics of 'heritage industries' and 'identity politics' see this phenomenon as a characteristic of the superficial cultural politics of postmodernity. And I think there's no doubt that a globalising system of cultural commodification is at work. But it's terribly inadequate to reduce the emerging subaltern and local productions that articulate with museums, cultural centres, and (inescapably) tourism to epiphenomena of a late capitalist, postmodern or 'Americanised,' world system of cultures.

Tribal museums, a proliferating movement, fulfil distinct, if connected, functions. They often perform heritage for both 'insiders' and 'outsiders,' differently. They are part of markets in native art which are unlike the older, ongoing economies in 'primitive art' – exclusively governed by Western taste and distribution. The new 'tribal' cultural productions are often significantly under native control. (One thinks of Aboriginal acrylics and video-making.) They are 'articulated' (a term I much prefer to 'invented') traditions: specific linkages of old and new, ours and theirs, secret and public, partial connections between complex socio-cultural wholes. To perform identity, to play the culture-game, is to be alive in postmodernity.

But the terms of this liveliness vary. And it's possible to articulate quite old, non-Western things, through the new languages of culture and identity. If a good deal of this becomes commodified, isn't it capitalist hubris to assume that's the end of the story. A closer, more ethnographic, look at particular sites of heritage collecting and performance than one gets from the political-economy systematisers, often tells an ambiguous, open-ended story. There is, undeniably, a systematic aspect to the proliferating politics of heritage, ethnicity and tourism. But it's a system of worlds in contact rather than a world-system.

Tribal museums/cultural centres, I argued in *Routes*, are innovations in a long history of cultural (re)appropriations – situations of ongoing, but always contested, inequality. My contact perspective also touched on sites of discrepant heritage like Fort Ross (the reconstructed Russian/Alaskan outpost in Northern California), on performed heritage and museum-collecting in highland New Guinea, and on the Mayan ruin and tourist site of Palenque. In each case I tried to focus on histories of local/regional/global articulation rather than

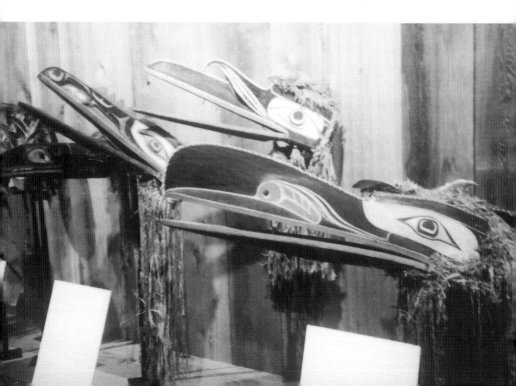

on systemically produced, commodified identities and differences. The 'world of museums' whose byways I began to follow (not just an expanded 'museum world') led me out of places like Paris and New York, modernist centres, and into a range of contemporary sites that can't be rounded up historically under the stop-gap language of 'posts.'

In _Routes_ you devote an entire 'experimental' chapter to the Susan Hiller installation you saw in London from the Freud Museum. How did you arrive at Hiller's work? As a fictional museum it is very different to the other museums you visit in _Routes_: were you consciously trying to play off the differences between the two?

I first learned about Susan Hiller in the early 1980s through the American poet, Barbara Einzig, who has since edited an important collection, _Thinking About Art: Conversations With Susan Hiller_. It was Hiller's anthropological/archaeological background, and her incorporation of issues from those disciplines in her painting, photography, videos, and installations, that most interested me. I suppose I assimilated her in to my utopian category of 'ethnographic surrealism.' She is deeply concerned with 'cultural' grounds for ways of perceiving and feeling, for the assumed real. She has worked with dreams, as everyday forms of knowing, in ways reminiscent of Leiris in his 'oneirographic' writings from _Nuits Sans Nuit_ (trans. by Richard Sieburth, _Nights as Days, Days as Nights_, 1987). Hiller is interested in expanded notions of writing and inscription. Her work draws – in anti-Primitivist ways – on tribal and other non-Western sources. Moreover, she has been very interested in matters of taxonomy and collecting, sometimes in ways similar to what Bataille and co. were doing in the journal _Documents_, at least as I reconstructed it. Crucially, for me, she adds a strong woman's perspective to this very masculinist tradition. I don't know whether Hiller would be happy or not to be aligned this way. There are

Masks from the potlatch collection, U'mista Centre, Alert Bay. Photo: James Clifford.

plenty of other sources. But it's how I came to her beautiful and unsettling work.

You say my piece on Hiller is about a kind of "fictional museum." Maybe it seems so because of its fragmented, subjective voice. But I see her presence in the Freud Museum as helping transform a shrine into a 'contact zone.' So the stakes there are the same as in the other museums visited in *Routes*. And the chapter is actually quite documentary in all its evocations; it doesn't make anything up. I happened to be in London and read about Hiller's installation in the newspaper. She used objects and texts arranged in archaeological collecting boxes to interrupt Freud's famous collections of Egyptian and Classical antiquities. She provided other 'origins,' other 'sources' of meaning and 'civilisation.' Drawing from Australian aboriginal materials, from female cults in Greece, from Joanna Southcott, from water-witching, from Mayan traditions, from African tourist art, from Sephardic Jewish history, etc. Hiller supplemented Freud's masculine, European, world view in a way that firmly pried open that tradition. It was never a question of consigning Freud to the junk heap of history, but rather of placing him in a complex intersection of histories. I felt immediately at home with this project, and thought it was a model of what I had, in different ways, been trying to do with Western anthropological discourses and institutions such as the museum.

I started out just trying to describe and appreciate Hiller's intervention. But, under her spell perhaps, I became as interested in the Freud Museum itself as in her poignant collection boxes. I heard a woman's voice wafting across from another room. Anna Freud, narrating home movies about her parents which played in a loop all day – films shot by Marie Bonaparte. Freud at Burlington Gardens, dying, surrounded by women. In the present museum, Anna's work-room rivals her father's. And her own life – with its travels, friendships, and clinical, intellectual work – pervades the space. Freud's own death here, a victim of Hitler's ethnic cleansing, writing

a book, *Moses and Monotheism* that undermined race purity (Moses the Egyptian), his struggle to sustain a kind of lucidity in the gathering obscurity, and the need to find a home, a garden, in exile – all this is intensely moving. It's moving even as, indeed because, one knows that the world Freud collected and cherished was crumbling around him and would be forever altered by world war and its aftermaths. (I feel similarly about another great 'end of the West' work of erudition written in exile during the war, Eric Auerbach's *Mimesis*.)

And then London itself – 'post-colonial,' 'diasporic' – crowded into the essay, which was already faceting almost out of control. I had to find a place, somehow, for Blake's transformative vision, and for another museum, of the city of London, which was just then holding a special exhibit called *The Peopling of London* (nothing but immigrants from the Romans on). So the piece turned into a kind of intersectional meander which, I'm afraid, is formally quite precarious. All the balls in the air for the reader to catch! *Routes* makes some demands on reading. It changes voice, rhetoric, and genre from 'chapter' to 'chapter.' Reviewers have complained about having to shift gears all the time; and of course different critics like half the pieces and hate the other half, for opposite reasons. But I thought it worth risking some confusion in order to – as my friend Jed Rasula put it – "aerate the academic text" while making explicit the different, serious registers (analytic, poetic, subjective, objective, descriptive, meditative, evocative, etc.) of thinking. We operate on many levels, waking and dreaming, as we make our way through a topic; but then we foreshorten the whole process in the service of a consistent, conclusive, voice or genre. I wanted to resist that a bit.

A
CO.
MÉTRA
ÉIADE
EIA D

GE-M
OST

CHEL
P

OGNE - M.

LOS OLVIDADOS

AFRICAN SONG

LITOR

ET EYCKHOUT AIME BONPLAND

NGE-AUTEUIL SANS ÉCRIT

JAN MAMRITZ

ONTAS YAZMIN —

ASMIN ETIENNE-LOUIS BOU

RANELAGH LA

EUKLID

PAUL

LA MU

⑨

| 8 | | 9 | | 10 |

FRIBE MINOTA

LES CANNIBALES

ehupft mi gespommen —

Experience vs. Interpretation: Traces of Ethnography in the Works of Lan Tuazon and Nikki S. Lee
Miwon Kwon

We are all ethnographers. Or so it would seem if we adopt James Clifford's generalised definition of it in his highly influential book *The Predicament of Culture*. According to Clifford, ethnography is simply "diverse ways of thinking and writing about culture from a standpoint of participant observation."[1] Distinguished from anthropology in its lack of aspiration to "survey the full range of human diversity and development," ethnography seems to appropriately suit the flux and partiality of (post)modern life.

> A modern 'ethnography' of conjunctures, constantly moving *between* cultures...
> is perpetually displaced, both regionally focused and broadly comparative, a form
> both of dwelling and of travel in a world where the two experiences are less and
> less distinct.[2]

It may be partly for this reason – the correspondence between the pervasive conditions of cultural displacement and ethnography's particularly displaced mode of operation – that it has resonated so strongly for artists, writers, and critics throughout the twentieth

de-, dis-, ex-.

century. In recent years, ethnography has extended beyond the realm of empirical research based on fieldwork in exotic, faraway places (such as locales in Africa, South America, Far East Asia, with presumed departure points in the 'civilised' West). As Hal Foster has elucidated in his essay "The Artist as Ethnographer," ethnography has become a dominant *methodological* model in the academy and elsewhere in the past decades, affecting the development of new historicism, cultural studies, and 'quasi-anthropological' art projects, among other cultural practices today.[3]

Why this particular ascendance of ethnography today? What are the socio-economic and political ramifications of this ascendance? How are artists enabled or disabled by the ways in which ethnographic imperatives reorganise their practice? And what is the relationship and/or difference between ethnographic authority and artistic authorship? While all these questions remain crucial for contemporary art as a whole, the present essay will focus on the last, by way of a comparative analysis of works by two young women artists – Lan Tuazon and Nikki S. Lee. Their respective photo-based projects signal, I think symptomatically, the divergent inheritance of the ethnographic question among a new generation of artists, an inheritance that seems to split the dialectical coupling of experience and interpretation, which is foundational to traditional ethnography based on participant observation. In so doing, they describe new dilemmas and problems for the 'artist as ethnographer.'

To clarify, the concept of participant observation encompasses a relay between an empathetic engagement with a particular situation and/or event (experience) and the assessment of its meaning and significance within a broader context (interpretation).[4] The history of ethnography and the methodological debates within the discipline for the past few decades could be understood in large measure as the shifting of emphasis from the former to the latter as the primary site of ethnographic interest. This shift has been forged by the growing criticism of the ways in which the rather vague and ineffable notion

of 'experience'; evoking "participatory presence, a sensitive contact with the world to be understood, a rapport with its people, a concreteness of perception," has come to function as evidence and confirmation of ethnographic authority.[5] The concern for a self-reflexive practice, wherein the situated and motivated position of the ethnographer him/herself is highlighted as an integral part of the production of knowledge, has been one of the central concerns of a more hermeneutically oriented group of anthropologists in recent years.

There has been, of course, an artistic parallel to this concern, not only in terms of artists taking up ethnography as an object of inquiry (such as Mark Dion, Jimmie Durham, Fred Wilson, James Luna, and most consistently Renée Green), but in more general terms of artists problematising the authority of authorship, especially their own. Critical projects through the 1980s and 1990s, which engaged the 'politics of representation,' self-reflexively incorporating within the work an acknowledgment of, and critique of, uneven power relations enacted by and through representations, can be seen to share ethnography's concerns to deconstruct the production of knowledge and the constitution of the authority of that knowledge.

But whereas experience and interpretation still seem to be tied to one another in a dialectical or reciprocal loop in critical ethnographic endeavours, I'm not so sure that the same can be said of recent artistic trends involving ethnography. Apparent in much contemporary art and encouraged in the confessional mode of popular media – from television talk shows to trauma drama – we see the overvaluation of 'personal experience' as the basis of true and reliable knowledge about culture and the self. Understood as the source of only real and authentic knowledge, 'experience' validates personal opinions and subjective feelings as an inviolable, irrefutable, undeniable terrain, no matter how uninformed such opinions and feelings might be. Thus, the attraction to the signs of experience (preferably of the unusual, extreme, painful, or dangerous kind), which would seem to give evidence of and confirm the legitimacy of a subject's authority

de-, dis-, ex-.

as the unique witness/author of a certain cultural knowledge, one that belongs to no one else.[6] This is the allure of Nikki S. Lee's work. Unquestioned in this process are the ways in which experience itself is culturally and psychically mediated as well as historically determined.[7]

At the same time, for those who have taken the critiques of authorship and the 'politics of the signifier' seriously (particularly in relation to the knowledge-power dyad), it has been problematical to assert the self as witness or author. Burdened by the need to account for the complex mediations involved in the construction of an 'I' who can claim an experience as one's own, as well as the inevitable partiality, instability, and uncertainty of this 'I,' many artists and critics have turned away from claiming a voice to deconstructing it (one's own, someone else's, or an institution's). With very few exceptions, the two processes tend to be held apart as if mutually exclusive. So that to speak authoritatively now (that is, to assert one's knowledge and know-how) is considered an oppressive act. In some instances, efforts to assess cultural trends or problems, to conjecture on their social, political, historical meaning and significance, are held in suspicion because there is a tendency to automatically align assertions of interpretive authorship with the exercise of *authoritarian* power. As a result, while there remains a critical energy around the deconstruction of interpretive processes, there persists a secret interdiction on interpretation itself.[8] It is within this framing that I wish to consider the work of Lan Tuazon.

Lan Tuazon, *The Anthropologist's Table*, 1999, detail.
All Tuazon images courtesy of the artist.

The Anthropologist's Table by Tuazon is barely a table. Its legs – skimpy and thin – are more like upstanding sticks than stable table legs. The top is thin too – a sheet of plywood seemingly plopped over to serve as a tabletop, balanced on the four scrawny legs. The table's proportions are confusingly diminutive. It is not large enough to be a proper desk; not small enough to be a child's plaything. It is, in fact, more accurate to describe this table as a diagram, a schematic drawing-in-space that stands as a sign of a mythical table rather than serving as a real piece of functional furniture. Yet Tuazon's table signifies no ordinary or generic table either. The surface of the table is covered with a sheet of glass, and encased beneath it is an array of objects: an open notebook, a stained coffee cup lid, a colourful range of Post-It tags, a drinking straw, a computer diskette, several Q-tips, a few photographs, a cigar and a matchbook, a stick of gum, an empty box of map tacks, a toothpick and a toothbrush, crumpled sugar packets, a lollipop, a bunch of coins, a handful of airmail envelopes, and a stack of unused Filofax pages. It is a motley collection of things, displayed as if someone had emptied their book bag onto the table to take an inventory of the items or to look for something misplaced. The table is a highly contrived 'picture' of the moment of the spill.

It is important to note that these objects are not actually *on* the table but rather embedded *into* its wooden surface; which is to say, each object is doubly encased – collectively beneath the sheet of glass and individually within the space that has been carefully carved out on the table following the contours of each item. Like a three-dimensional shadow, these contoured depressions echo and hold the shape of the objects, furthering the photographic logic of a captured frozenness of the arrangement. Set within this image-table are close-up photographs of a different arrangement of objects on yet another table (or perhaps the same table at a different time?). In addition to sundry items like an ashtray, pen and cigarette – which together would signify the privacy of a study space – these photographs reveal

Lan Tuazon, *The Anthropologist's Table*, 1999.

portions of an open book and magazine.[9] The book is *The Gentle Tasaday: A Stone Age People in the Philippine Rain Forest* by journalist John Nance, a novelistic report on the "lovely and beautiful" cave dwellers who were accidentally discovered in 1971 and who apparently had had no contact with the modern world until then.[10] The magazine by contrast shows a *Newsweek* story from a few years later on the scandal following the discovery and charge that the Tasaday tribe was a grand hoax with ties to the corrupt Ferdinand Marcos regime.[11]

On the face of it, it would seem Tuazon's juxtaposition of these two archival documents is meant to provoke the awareness of ethnographic ventures as one steeped not in truth-finding but in fictional projections. The Tasaday case is an extreme example of this as it exposes the ways in which such projections come to serve ideological and political purposes most literally. But the elaboration of Tuazon's set-up, the careful art direction of the tableau, and the extent to which the two photographic images are visually marginalised in the overall table-sculpture, would indicate something a little different at work. For what the viewer is asked to contemplate is not so much the Tasaday controversy *per se* (no more information is given beyond the visible bits of the narrative in the photographs), or the various desires operating among ethnographers and the popular press for the 'primitive' other, or the questionable nature of ethnography as a quasi-scientific enterprise. Rather, even as these aspects are inflected in the work, the viewer is directed to focus on an absent, anonymous figure and his/her things as a means to access the conditions of identification, fantasy, confusion, and ambivalence that circumscribe the milieu of critical interpretation. Put a little differently, the object of the inquiry is not only the problematic construction of ethnographic authority, but, more centrally, the desire to deconstruct or disarticulate that authority.

The distinction might be better clarified if, for instance, we think of the work of Renée Green from the early 1990s as a touchstone. In several projects from this period, Green appropriated institutional presentational conventions to expose the collusion of ethnography's primitivist fantasies with the political and social realities of colonialism. In projects like *Import/Export Funk Office*, she explicitly adopted the role of the ethnographer herself and revealed that ethnography's voyeuristic 'textualising' of the other is primarily a displaced means of confirming a self-definition.[12] Tuazon extends the lessons of an appropriational critique of ethnography to map the subjective (domestic) space of such investigational endeavours.

Nikki S. Lee, *The Hispanic Project*, 1998.
All Lee images Courtesy of Leslie Tonkonow Gallery, New York. 81

Ostensibly at 'home,' temporally and spatially distanced from the fieldwork arena of participatory experience – the direct encounter or exchange between the ethnographer and the other – *The Anthropologist's Table* presents a space of solitary contemplation punctuated with mediational materials: magazines, photographs, books. These materials, already the products of various fantasies, projections, displacements and desires, collectively function as a second-degree interpretive screen of fantasies, projections, displacements and desires for our phantom anthropologist (or so the viewer imagines). At the same time, the cluttered objects of habit and daily routine intermixed with the interpretive materials on the table, left for the viewer as if they were a bunch of random clues to a puzzle or pieces of evidence to a crime, defines the phantom anthropologist him/herself as a site of another set of fantasies, projections, displacements and desires for the viewer (interpreting the interpreter).[13]

Nikki S. Lee, *The Punk Project*, 1997.

In this matrix of multiple subject positions, the viewer circulates. The objects on the table hint to the viewer the possibilities of many narratives, but only the possibilities. The historical incident of the Tasaday case, the ethnographers who participated in the incident, the problematic construction of ethnographic authority, the artist herself as a positioned commentator on these issues... none of these aspects, while obviously present in the work, ever comes into focus as a dominant theme. The viewer continuously moves through the various interpretative paths, with possible subject positions remaining open yet veiled. But the point of the work, I think, is not to simply make available many interpretive possibilities for viewers (as reader-authors in their own right), although such inconclusiveness has come to be considered a virtue in certain contexts. More precisely, *The Anthropologist's Table*'s edge comes from the fact that, caught in a web of signifiers that continuously defer the referent and resist certainty (as noted earlier, the table is not even a table but a sign of one), the viewer ends up occupying at least two interpretive positions simultaneously. For it is ultimately impossible to separate the position of the phantom anthropologist and the self/viewer as the 'detective' that is seeking to unmask/critique this anthropologist and his/her activities. In *The Anthropologist's Table*, Tuazon makes it impossible for the viewer to objectify or other the objectifying and othering practices of the anthropologist.

If Tuazon's effort, circling around the problem of interpretation, is a stubborn refusal of a reliable referent, signalling the impossibility of unmediated experience and knowledge, Nikki S. Lee's project runs in the opposite direction. Since 1997, Lee has been photographing herself (or has had herself photographed by a friend) in various subcultural guises – as senior citizen, swinger, punk rocker, young Japanese tourist, Hispanic, yuppie, lesbian, among others. Insinuating herself into the life of such groups for two or more weeks at a time, she adopts their appearance – the signifiers of their identity in terms of dress, posture, attitude, activities – to such a complete extent that

she can easily pass for one of them. These 'going native' performances are documented for posterity and the mainstream art world through snapshot photographs, which serve to evidence the acceptance of the artist as an insider by more permanent members of the group.

Based on some very superficial similarities (i.e. dressing up to perform an identity for the camera), Lee's work has been often compared to Cindy Sherman's untitled film stills.[14] Even more problematic has been various critics' characterisation of Lee's 'fieldwork' as a critique of social stereotypes or an engagement with complex theories of the cultural mediation of identity and subjectivity. But even a cursory glance at some of the artist's statements, in conjunction with the series of photographs themselves, would reveal the extent to which Lee's 'fun' celebration of the performativity of multiple identities cannot support such claims.[15] Indeed, to see her work as the "presentation of others who are potentially within her,"[16] or as the exploration of the "endless possibilities for self-alteration,"[17] or as an indication of the artist's acknowledgment of an empathetic continuity between the self and other, and then to draw from such readings the conclusion that somehow the artist is involved in disarticulating the conception of the modern subject, is to completely misrecognise the thrust of the work (and to misunderstand what it means to critically address the construction of the modern subject). As is prevalent in many other contexts, the notion of multiplicity of identities offered here is a convoluted turned-inside-out version of 'We Are the World' that reaffirms the subject as autonomous and centred once again.

As Hal Foster has stated, "multiplicity of men do not necessarily trouble the category of man."[18] Further, he has noted that

> othering of the self... is only a partial challenge to the modern subject, for this othering also buttresses the self through romantic opposition, conserves the self through dialectical appropriation, extends the self through surrealist explorations, prolongs the self through post-structuralist troubling, and so on.[19]

de-, dis-, ex-.

While Lee's work does not measure up to the sophistication of such a critique, it does recall this problematic nonetheless. And it is to the extent that her work recalls such analysis (without actually learning from them), while at the same time echoing the identity-switching television fantasies like "The Pretender," that her work has found such a strong critical and commercial reception in the past couple of years.[20] This is quite disturbing considering how such work abstracts subcultural communities as fashion tableaux, how it reduces the crisis of identity to a game of costume changes, and, most importantly, how it ultimately *refuses* the other.

Nikki S. Lee, *The Young Japanese*
(East Village) Project, 1997.

But the extraordinarily enthusiastic market and critical embrace of Lee's work is of interest insofar as what she really delivers is 'experience,' evidence of an extended encounter with the 'other' that satisfies the general "longing for the referent"[21] and the desire for a proximate relation to the 'real' in the majority of her art audience. This is why, in the critical reception of Lee's work, much has been made of the snapshot-like quality of her images – the casualness of the poses, the subjects' direct-address of the camera, the date and time stamp on each shot, the lack of a slick professional finish to the prints.[22] While these attributes are usually pointed to as indications of the artist's ostensibly rebellious lack of concern for high art, what the critics are really cathecting to is the capacity of her images to signify spontaneity and continuity with the other's everyday life. That is, the snapshot aesthetic verifies, even guarantees, the imagined authenticity of Lee's experiential engagement with the subcultural community of her choice. Going further, the snapshots function to falsely signify 'intimacy,' a quality of extended engagement normally based on deep knowledge, rapport, and trust. The seemingly unstudied informality of the photos belie the artist's status as outsider art director and model, who, even in absorbing the identity of the other, will render the other into a prop for the self.

Nikki S. Lee, *The Seniors Project*, 1999.

Lee's photographs in the end fall in line with the tried and true technique of modern ethnographic authority – "you are there... because I was there." And, curiously, because Lee is recognised as part of a subcultural group herself (Korean-American), her staking such a claim of authority is received by the mainstream art world as all the more convincing. Certainly, the artist understands the proximity of ethnography to commercial tourism (an earlier incarnation of the current performance/photo project was *The Tourist Project*). But rather than disturbing or complicating the voyeuristic desire and primitivist expectations that fuel ethnography and tourism, Lee fulfils them by objectifying herself, collapsing herself into the other *as* an other, serving happily as a 'native' tour guide. I am uncertain as to whether this is propelled by utter cynicism or naiveté; but I would like to believe that it is the latter.

While the rush towards experience might indicate an instinctive distrust of the ways in which information, knowledge, indeed 'experience' itself come to us pre-packaged, commodified, and 'interpreted' today, such a tendency seems an ineffectual response to the conditions of the dominant culture. For the series of performative projects that Lee has pursued over the past three years is a rather disturbing admittance of the emptiness of the self – unwilling, perhaps unable, to engage culture as a responsible and self-reflexive participant observer. (Or rather, misrecognising the emptiness as a reflexive plenitude.) Clearly, I find the overvaluation of experience far more problematic than the overemphasis on the interpretive process in how it forgets the historical and social determinants of the very concept of experience. But then again, Tuazon, even as she scrutinises the processes of mediation that would inflect interpretation, ultimately withdraws from the task of interpretation too. In both cases, although in different ways and to different degrees, there is a lack of recognition of the *relational* dynamic between experience and interpretation, between participation and observation. In Nikki S. Lee's case, experience is thought to be beyond the realm of interpretation,

as if it were transparently meaningful onto itself. In Lan Tuazon's case, experience is completely trapped within interpretive mediations, so circumscribed that participation and observation become indistinguishable.

These turns pressure the problem of authorship in new ways and reveal the continued centrality of ethnography as a methodological paradigm in contemporary art. Or rather, the work of the two artists that I have highlighted in this essay helps clarify the ways in which (aspects of) the ethnographic paradigm has been pulled in divergent directions – along the experience/interpretation axis – in recent years. As artistic negotiations in/of what James Clifford has characterised as "a pervasive condition of off-centredness in a world of distinct meaning systems, a state of being in culture while looking at culture, a form of personal and collective self-fashioning," Tuazon's and Lee's work model very different visions of the 'artist as ethnographer.'[23]

Footnotes

1 Clifford, James, *The Predicament of Culture: Twentieth Century Ethnography, Literature, and Art*, Cambridge, MA: Harvard University Press, 1988, p. 9.

2 Clifford, *Culture*, p. 9.

3 Foster, Hal, "The Artist as Ethnographer," *The Return of the Real*, Cambridge, MA: The MIT Press, 1996.

4 Clifford, *Culture*, pp. 34–41.

5 Clifford, *Culture*, p. 37.

6 The photographic works of Nan Goldin and Wolfgang Tillmans come to mind right away. Although their projects are not meant to be ethnographic investigations, it can be said that they satisfy a certain ethnographic curiosity on the part of the audience.

7 See Joan W. Scott, "Experience," in *Feminists Theorize the Political*, Judith Butler and Joan W. Scott, eds., London: Routledge, 1992.

8 Thanks to Helen Molesworth and Frazer Ward for discussions concerning this problem.

9 These photographs, used as just an element in *The Anthropologist's Table*, have been exhibited individually in an enlarged format in a series entitled *Ethnofictions*.

10 Nance, John, *The Gentle Tasaday: A Stone Age People in the Philippine Rain Forest*, New York, NY: Harcourt Brace Jovanovich, 1975. On the book jacket, Nance's effort and the Tasady tribe are described in a language that recalls an advertisement for a television mini-series: "He details the Tasaday's discovery by the outside world in 1971 and their first years of contact with modern society – from their terrified first encounter with a helicopter, which they thought was a giant insect, to their itch to venture outside their mountain sanctuary to the 'flat world' beyond. He tells of efforts to protect them from twentieth-century dangers, including the threatening presence of outlaw gunmen who sneaked to their caves to 'get a taste of the Tasaday' – a people with no weapons and no known words for enemy or war."

11 On the controversy surrounding the Tasady case, see the following articles: Carol Molony, "The Truth About the Tasaday," *The Sciences*, September/October, 1988; Aram A. Yengoyan, "Shaping and Reshaping the Tasaday: A Question of Cultural Identity – A Review Article," *Journal of Asian Studies*, August 1991; Jean-Paul Dumont, "The Tasaday, Which and Whose? Toward the Political Economy of an Ethnographic Sign," *Cultural Anthropology*, vol. 3, no. 3, 1988.

12 See Clifford, *Culture*.

13 Thanks to Doug Ashford for conversations concerning the work of Tuazon. His idea of the detective as an analogous figure to the ethnographer was helpful in thinking through *The Anthropologist's Table*.

14 See for instance, Roberta Smith, "More Space for Young Artists," *The New York Times*, February 19, 1999, and Holland Cotter's review, "Nikki S. Lee," *The*

de-, dis-, ex-.

New York Times, September 10, 1999. Cotter notes that "the kind of transformation that Cindy Sherman enacts in the privacy of the studio, Ms. Lee takes to the street." But such comparisons simplify Sherman's work and miss the point of Lee's.

15 The artist has stated: "When we change our clothes to alter our appearance, the real act is the transformation of our way of expression – the outward expression of our psyche." And "Essentially, life itself is a performance." Quoted in Marie de Brugerolle, "Nikki S. Lee," *Documents sur l'art*, Fall/Winter, 1997/98, n.p.

16 de Brugerolle, "Nikki S. Lee."

17 Cotter, "Nikki S. Lee."

18 Foster, "The Artist as Ethnographer," footnote no. 21.

19 Foster, "The Artist as Ethnographer," p. 179.

20 This is a popular prime time television series in the United States in which the hero/protagonist performs a new identity each week, rectifying all kinds of social injustice while searching for his 'real' identity.

21 Foster, "The Artist as Ethnographer," p. 182.

22 In addition to the articles and reviews by Roberta Smith, Holland Cotter, and Marie de Brugerolle as already noted, see Nancy Spector's introduction in the exhibition catalogue *Guarene Arte 99*; Barry Schwabsky, "Nikki S. Lee," *Artforum*, September, 1999; and Ingrid Schaffner, "Tourist Snaps," *Art on Paper*, January–February, 1999.

23 Clifford, *Culture*, p. 9.

GALE

JEUR

A.L.P.

BILLE-EN-COURS

BILLANCOURT

ROSA LUXEMB.

'LES AMAZONES'

ARC

JEAN DE LÉR

FRANCE ANTARC

RUE DE LA POMPE

AVENUE GEORGES MANDEL

TROCADÉRO-

TAPIR

LE CRU

PLACE

Léon Batti

IÉNA

ALM

⑪ ⑬ ⑭

| 11 | 12 | 13 |

LE W

⑥ ~~NATION~~ INDO CHINE
CHARLES DE GAULLE-ÉTOILE

BRAZZAVILLE

PRIMA PORTA

① ~~CH~~
 ~~PÔ~~

COM

COMING SOON
BEING MADE

BILLE-EN-COURS

BILLE EN
COURT DE
Tennis
COUR
YARD

CHRONIQUE SO

L'HOMME
CUIT LE
LIOT

MARCE
CARP
LEJO
FRANK

15

RBEN
DE VINCENNES
NEUILLY

N TOTALE

ALEUSE

The Art of Ethnography:
The Case of Sophie Calle

Susanne Kuchler

The art of ethnography turned artwork is the subject of projects by many a contemporary artist. Among them, though, the French artist Sophie Calle excels, with her witty and candid visual explorations of the ethnographic in contemporary culture. Through an engagement with her work we may learn vital lessons about the dilemma facing visual culture today, in which memory and materiality are losing their bearings.

Calle and the American writer Paul Auster, with whom she entered into a creative partnership in the late 1970s, have recently been the subject of heightened critical attention. Calle, colluding with Auster, has set out in numerous projects to investigate the subjectivity of those who pry into the lives of others. Mingling fact with fiction, Calle became the basis for the Maria Turner character in Auster's novel *Leviathan*. In the descriptions he made of Maria many elements correspond to Calle's life; but Auster has also introduced rituals that are totally fictional. In order to get closer to Maria, Calle decided to obey the book, following a chromatic diet and performing activities which begin with the same letter of the alphabet. Recently, in response to this, Calle reversed the process. She requested and documented a

de-, dis-, ex-.

new narrative written for her by Auster about a fictional character called Sophie whose story she would proceed to live out. The result was a three-part volume, *Double Games*, part of which is the *Gotham Handbook: Personal Instructions for Sophie Calle on How to Improve Life in New York City*.[1]

Both Auster and Calle are concerned with how the social space surrounding people frames them. In particular they highlight the dependency of the subject upon the construction of an object, which alternately, turns persons into objects and objects into persons. Typically, installations of Calle's many projects document a process of observation and data gathering which uses strategies of surveillance, reportage and documentation that are represented in the form of photographs, lists and obsessive text.

There is a marked difference between Calle's early work, and her later work (post-1992). Her earlier work, such as *Suite Venitienne* and *L'Homme au Carnet*, make art out of other people's lives. *Suite Venitienne* is a diary of a project she undertook in the Bronx. It initially uses photographs and a short text in order to document Calle's approach towards the passersby who, every day at the same hour, take her to their favorite places. One day in January 1980 she follows a man in the street but loses his track. The same evening, in a party, she meets him again. He goes to Venice and she decides to follow him. This activity formed the beginning of the Venetian Suite, eventually published in book form. Wearing a wig, Sophie follows him in Venice. She tracks him down with a camera and makes an hour by hour photographic and written report of her days. Sometimes she loses his track or finds herself face to face with him. She reports her shivers, her fears with the excitement of a love affair.

Calle's use of the ethnographic present tense and also her staging and manipulation of self/other relations draws heavily on the ethnographic model, in which fieldwork is used in order to reconcile theory and practice and to reinforce the basic principles of the participant/observer tradition.[2] While this early work appears to be

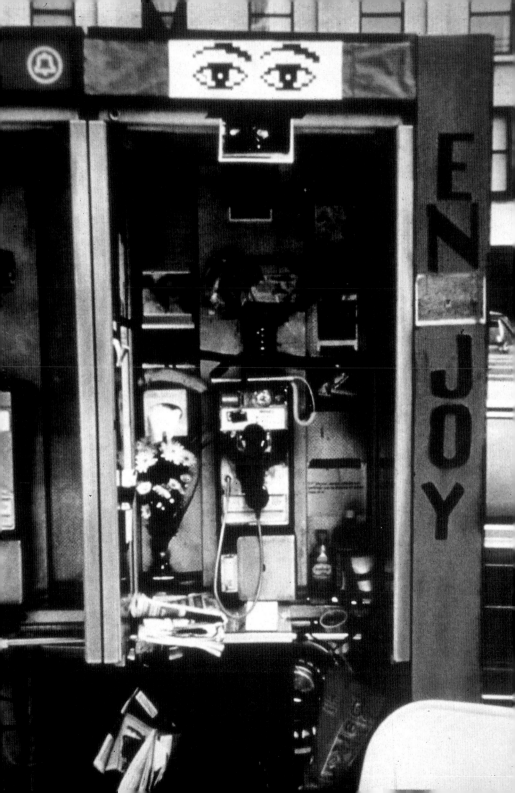

concerned with the condition of the postmodern subject (by using photography as a method of ethnography), Calle's later work shifts to a concern with the person-like qualities of artworks which become the nexus of social relations. For example in *Double Games*, living out Auster's fictional character Maria, Calle takes to the streets of New York, smiling at strangers, letting them talk to her for as long as they like, distributing food and cigarettes, and cultivating her own spot on the city streets. Calle chose as her base a phone booth, which she then faithfully reconstructed in her installation, making it comfy with a chair, small change, reading materials, food and drink, and decorating it with flowers and photographs. The most important parts of this installation are the lists in which Calle notes the number of times strangers smiled at her and returned her smiles, cigarettes were offered and taken, the number of minutes each conversation lasted, and so on. In *Double Games*, ethnography thus emerges not just as a method of making art out of others' lives, but as a site of commemoration which frames social relations.

As well as the obsessiveness which characterises much of her work, Calle's trademark remains consistently that of 'the self-styled ethnographer of the everyday,' Ethnography is generally understood as a method of 'participant/observation,' a concept developed in the 1920s by Bronislaw Malinowki, who became one of the key figures in the development of modern research techniques in anthropology using such observation methods 'in the field.'[3] Participant observation has continued to be used as the basic method that enables one to capture how others live their lives, uncovering the salient dynamics of social relations, of attitudes and beliefs, by noting the many verbal, gestural and material exchanges which compose the minutiae of everyday life. As participant observation necessarily reflects a subjective experience, the diary which forms the basis for secondary listings of observations says as much about the ethnographer as it does the site and subject of the fieldwork.[4]

Calle appears almost self-consciously to work through the method

Sophie Calle, *Gotham Handbook, Keep Smiling*, 1998.
All images courtesy of Camden Arts Centre.

of ethnography, dissecting it, as it were, into a number of consecutive stages, each taking the form of separate projects. Her early projects concentrate on situating the ethnographic. Here, the ethnographic is 'found' in situations which are born out of chance and yet become the platform for recollections whose documentation and installation turns the project into an artwork. In *l'Homme au Carnet* she builds a profile of Pierre D. – a stranger whose address book she finds by chance – by contacting everyone in it and asking for their thoughts about him (these were then published in *Liberation)*. Similarly, *L'Hotel* is composed of a series of photographs Calle took while working undercover as a hotel chambermaid, each portraying the incidental, like the clues observed by Sherlock Holmes at the scene of a crime – shoes thrown beside a bed, tissues spilling out of a handbag, dirty linen, etc. Peculiar to these projects is that Calle draws herself into the setting, from an image of the artist – topless, veiled and sporting a blonde wig – performing striptease in a Parisian dive, to photographs taken of her by a private detective hired by Calle herself. Initially intended "to provide photographic evidence of my own existence," such a technique also draws attention to the ever-changing viewpoint of the follower and the followed. This idea receives its heightened articulation in *Suite Venitienne*, whereby Calle follows Henri B. to Venice, only to turn the project around in *The Shadow* in which she arranges to have herself followed.

Comparing her early installations with her later work, we can see that the evidence for situations which mark the plot of each project increasingly comes to consist, not of words or images, but of the materiality of things. This retraces a tradition which reaches back to such ostensibly diverse figures as Giovanni Morelli, Sherlock Holmes and Sigmund Freud, all of whom changed the nature of what evidence can be.[5] In *Suite Venitienne*, evidence still takes the form of photographs which obscure rather than reveal their object, betraying more about the follower than the followed. In her later work, *Double Games*, however, and even more so in the subsequent

de-, dis-, ex-.

Birthday Ceremony (1998), materials figure as active components of social relations, providing clues which entice the viewer to reconstruct the site of ethnographic intent. Here, the ethnographic emerges as an incremental part of the installation, consisting of allusive thought processes which are difficult to reconstruct.[6]

Calle has not only created new pieces of work, but she has also reworked existing installations in ways which have led to, for example, different incarnations of *Suite Venitienne*. These installations range from the photographic to the aural, as exemplified by the 1999 version of *The Confessional Piece*, in which Calle sits in a confessional box narrating the diary of *Suite Venitienne*.[7] Other installations are also inter-articulated, as they explore the relation between the indexical and the material, the subject and the object. In *Double Games*, for example, the things given or taken, be it a smile or a cigarette, are present in the installation merely in the form of a list, thus suggesting the primacy of the indexical in the fashioning of social relations. In *Birthday Ceremony*, a poignant shift is made towards exploring how a thing, anything in fact, may be both active in social relations and simultaneously turned into an artwork.

This insight, namely that a thing given provides not just a clue for a social relation but is already an artwork (*Birthday Ceremony* is the only installation which is not represented by photography, but by the objects themselves) foreshadows the most recent anthropological theory of art formulated by Alfred Gell in his posthumously published *Art and Agency*.[8] Challenging the logocentric paradigm still rampant in anthropological theory, Gell argues for the primacy of the object-person relation as articulated in the act of exchange in which objects become person-like, capable of agency in relation to other persons. The object-turned-person, displaying 'abductive' tendencies, is none other than what we conventionally term 'art' – an insight which brilliantly confounds the remnants of the distinction between art and craft made in the nineteenth century which still lingers on in so many definitions of art.

Birthday Ceremony consists of a series of cabinets containing a myriad of differently textured things, each one serving as evidence for an unfolding self-other relation. This work is Calle's first major sculptural installation, conceived especially for "Art Now 14" at the Tate Gallery, London. Although made in 1998 the work's origins are in the years 1980 to 1993, when Calle invented and sustained a series of private rituals around her birthday. Over this period, with the occasional exception, Calle held an annual dinner party on or around the evening of her birthday. To each celebration she invited a group of friends and relations, the precise number of invitees corresponding to the age reached on that day, but with one additional, anonymous guest.

The *Birthday Ceremony* brings together fifteen medicine-like cabinets based on the design of the original, which had been given to Calle by her father. Thirteen individual cabinets, and one pair, each contain the gifts of a single year. The gifts, which are displayed unwrapped, range from the banal to the bizarre. They include works of art, tokens of affection, books and letters, junk and antiques, plastic trivia, items stolen from a restaurant, bottles of wine, chocolates and so on. Most cabinets are crammed full, reminding one of images of curiosity cabinets in the age of Enlightenment. One has to strain one's eyes to see through the glass on which is etched a list of items contained in the cabinet from 1981. The first part of the list reads: bouquet of flowers, book by Mario Vargas Liosa *La Maison verte*, a construction by David Rochline (mirror, gilded wood, marshmallows, chocolates, candies and plastic doll), a pair of Jean-Charles Brosseau cream coloured knitted cotton gloves, a bottle of eau de vie labelled *Pour les 28 ans de Sophie Calle*, a compass, and so on. After the list Calle has included the following remark on it: "All twenty-eight guests appeared. The stranger gave me the black mask. Because of its irresistible utility, the washing machine is represented by a manufacturer's guarantee. By giving me this present my clever mother managed to subvert the ritual."

de-, dis-, ex-.

Framed behind the glass, the gifts appear to arrest the relationships they evoke. The effect of the gift marking a passage and thus even 'making' time is heightened by the 'absent' gift, notably identified as the one presented to Calle by her mother, which, too large to put behind glass and/or too 'useful' for Calle to sacrifice it to the cause, is substituted by a guarantee. Here, a relation of 'kinship' is marked as absent, while those who are included in the form of their gifts remain anonymous, as in *Double Games,* where those who exchange smiles or cigarettes remain without names. In *Birthday Ceremony* names of things take the place of names of persons, allowing abductive reasoning to trace the mysterious donor, even in the case of 'mother' and 'father,' who appear as a listing of named things to which Calle became attached. Calle appears here to point to the place that knowledge and things hold in the way Euro-Americans deal with kinship relations.[9] Because, as Strathern recently pointed out, "of its cultural coupling with identity, kinship knowledge is a particular kind of knowledge: the information (and verification) on which it draws is constitutive in its consequences."[10] Kinship knowledge in Calle's world remains concealed within the gift, which does, however, simultaneously reveal more than words can ever do.

One may evoke any number of anxieties, such as Calle's self-acclaimed fear of being forgotten, to explain the *Birthday Ceremony.* Yet the theme of the gift, accentuating the mutability of subject and

Sophie Calle, *Suite vénitienne,* 1980–1983.

object and dramatising social relations as they unfold, is too consistent with Calle's other projects to allow subjective reasoning to have sufficient explanatory force. In fact, if she did not actually think of the *Birthday Ceremony* as an artwork more than a decade ago, Calle would have had to have invented it as a logical and epitomising conclusion to her work.

The gift has been given the most outstanding treatment by generations of ethnographers writing in the tradition set by Marcel Mauss' well known and influential *Essai sur le don* which first appeared in 1924. Whether inscribed within this tradition, or one that traces itself to George Bataille's articulation of a general economy of expenditure, philosophers, literary critics, and literary theorists have, with increasing frequency, reflected upon questions of gifts, gift giving, reciprocity and exchange.[11] Yet, perhaps equally as important for a perspective on the relation between the artwork and the gift, is recent historical research on collecting. For this body of research has brought to light an intrinsic relation between the gift, the collectible, and the notion of the ethnographic as it emerged at the close of the eighteenth century. Not only was the object that was collected and housed in curiosity cabinets simultaneously the object of ethnography, but it was also a gift to be given or received as a memento of indebtedness. As Pomian reminded us, it was the exchange value peculiar to these objects which enshrined their unceasing potency as the inner workings of a sacrificial economy that came to form the bedrock of the institutionalisation of the arts. The importance of a sacrificial, gift-based object, visibly arresting pure exchange value, had been heightened by the efflorescence of industrial economy, and yet many studies barely considered its role beyond the confines of mercantile forces.[12] The intense revival of interest in the gift in anthropology and related disciplines in the early 1970s coincided with the demise of proprietary rights extended to objects and the impending shift to an intellectual economy where rights were extended to invisible resources and assets.

de-, dis-, ex-.

The Euro-American understanding of the gift defines gifting as "transactions within a moral economy, which [make] possible the extended reproduction of social relations."[13] Recent anthropological theories of gifting illuminate the very idea of there being part-societies ('moral economies') that "typically consist of small worlds of personal relationships that are the emotional core of every individual's social experience."[14] Instead of gifting being defined as an altruistic gesture towards an environment/society which contains persons, anthropology points to the global dimensions of persons, sociality being integral to them. The partner in such exchanges is always another specific person and, as all such encounters are interpersonal encounters, "they convey no special connotations of intimacy. Nor of altruism as a source of benign feeling."[15]

Calle's installations resonate the dismantling of Euro-American notions of gifting and of the person fuelled by ethnographies.[16] The small worlds of personal relationships, composed of the familiar, the strange and the forgotten, are carefully documented in the photographs and lists of which her artworks are composed. The details of the everyday she records, though always specific in terms of place and time, have also a universal quality, thereby negating the notion of an environment containing persons. Most importantly, the installations create a picture of Calle, the person, comprised of social relations of which we, the spectators of her installations, are a part. Such relations are either made to appear, or do appear, in their making, as every installation displaces a former one. As Calle's identity as a person is part of the process of enchainment, Calle does not emerge as a free agent. It is not her desire/drive/need that propels the installations into existence, but "those other persons" – from Henri B. in *Suite Venitienne* to the character Maria in Auster's novel or to 'mother' and 'father' in *Birthday Ceremony*. As all encounters are thus interpersonal encounters, they convey no special connotations of intimacy.

The small worlds of relationships comprise activity of a cosmic order in photographic installations such as *L'hotel*, in which details of

habitation become the token of inter-personal encounters into which the spectator is drawn as much as Calle herself. The photographic record details Calle's observations as chambermaid that are progressively substituted by the traces left by herself. The photographs emerge as gifts, yet as gifts that are never free standing: they are attached to a source ('Calle') in being destined for another ('the spectator of the installation'). The intimate space of *L'hotel* breaks down the distinction between the political economy dominated by commodities, of which the installation is a part, and the 'small world' of the moral economy, of consumption and desire documented in the installation. Intimacy is put to use as part of the ethnographic method, but is denied any special connotation as it is routinised as an interpersonal encounter that is no different from any other encounter.

Other installations, such as *Le Regime chromatique*, in which text and colour photos describe the meals that Maria (Calle's Auster

Sophie Calle, *Birthday Ceremony*, 1980–1993.

character) eats in Auster's book *Leviathan* from 8–14 of December, 1997, with each day of the week corresponding to a different colour, suggest the pivotal role of the person-object relation in the expression of sentiment. Sentiment, we are led to see, is not emanating outward from the person, which appears as autonomous and charitable, but is an inseparable part of a process of personification "that converts food and objects and people into other people."[17]

Calle's installations trace successive moments of displacement of fact and fiction, and of persons and property. The response to her installations has been overwhelming, evolving out of contemporary revisions of such concepts that have been shaped to a large extent by Marylin Strathern's now famous notion of fractality. Fractality applies to persons and objects alike in ways that radically challenge the assumption of person-object relations with which we are familiar. Our own expectation of the way persons extend rights to objects is embedded in Hobbes' theory of society which asserts the need for moral, religious and legal law and practice to integrate persons into existing social networks. Social relations, we assume, are the result of the successful mediation of person-object relations and are thus external to them. In contrast, Strathern asserts the pre-existence of sociality within the concept of person and object. Composite, individual and androgynous persons take the place of the individual while asserting the importance of processes of 'decomposition.' The decomposition of persons is effected in acts of exchange by the gift's capacity to externalise internal relations.

The model of the fractal person serves as an enlightening commentary on Calle's photographic installation of *Suite Venitienne*, which appears to miss its object or to capture it obscurely, betraying more about the follower than the followed. The artwork enables Calle to 'find herself' for the moment captured in the scene in which the other appears (albeit as a forever vanishing object of desire). Calle emerges as a discreet person in the act of separating out the social relations of which she is composed. Yet, in no other installation

is this idea carried forward with as much clarity as in *Birthday Ceremony*. Here, the act of separation, which allows internal relations to appear in object-form, is part of a ritual process (the birthday), which although a temporary phenomenon, is internalised and embodied as image. The cabinets, within which the relations thus decomposed are enshrined from year to year, are the material evidence of such processes of embodiment. Described as 'gifts,' each assemblage appears as a memento of Calle's world of personal relationships which are replaced through the substitution of a counterpart. Although Calle elicits each such substitution, the gifts she consumes are not coming from the 'outside' as an abstract impersonal matrix which may contain other persons or things as its context (environment /society), but from partners/friends whose relationship has been nurtured. Calle's growth, or the time whose passing she comes to embody, is thus registered in the actions of other, specific persons.

As in her early installations, the 'stranger' plays a significant role in *Birthday Ceremony*. The apparent obsessivenes of pursuit, which gradually turns the stranger into the partner of an interpersonal encounter in *Suite Venitienne*, is declared as metaphorical and strategic in *Birthday Ceremony*. Here, the stranger appears as the significant object which externalises hidden future relationships which come to comprise Calle. Yet the stranger's act of gifting also works to substitute effect, in that this gift is a substitution of a previous, impersonal one. A significant shift is thus achieved from the consideration of the changing Euro-American concept of person to processes of personification in which objects play an incremental part.

This inclusion of the impersonal matrix of environment/society into the personal space of the cabinets and the cycle of gifting they represent adds a new twist to Calle's reflections on personification. Not only are we witnessing the dismantling of the Euro-American notion of person as the autonomous well-spring of desire, but we are led to question the autonomy of objects that take on person-like qualities as artworks and gifts. As the stranger's gift serves as a kind

Sophie Calle, *The Chromatic Diet*, 1998.

of signature within each cabinet, making it unique in comparison with the others (while simultaneously subsuming it into the cycle of gifting) so the cabinet as a whole appears at once as personified object capable of actively eliciting new substitutions, and as dependent upon the acts of others.

In *Birthday Ceremony*, moreover, the stranger's gift is merely part of a 'technique of enchantment' which attracts attention to the object and turns the cabinet within which it is contained into an artwork. While it appears that 'any' object may serve as 'gift,' in fact the objects which are contained within the cabinets are carefully selected and strategically placed. As our eyes wander back and forth between the listing of items etched on the glass of the cabinet and the objects contained within, we cannot resist attempting to reconstruct the thought that went into the choosing of each item and its positioning within the cabinet. Before we know it, we find ourselves drawn into an interpersonal encounter, as the cabinets bring Calle close to us. They appear to reveal more about Calle and her relationships than a direct observation of her world would allow us to see.

The list, which in previous installations served as evidence of an ethnographic method which makes art of other people's lives, emerges in *Birthday Ceremony* as the technique of situating the ethnographic. Etched into the glass of each cabinet, the list holds our attention and draws us further into the small world contained within. And suddenly, as if by chance, we see that what we thought was an artwork – designed as installation for and within the abstract context of the gallery environment – is in fact "the living person personified."[18] As it finds its subject in objects turned art, ethnography may never be the same again.

de-, dis-, ex-.

Footnotes

1 Shown at the Camden Arts Centre in London February–April, 1999.

2 Although Malinowski is probably the anthropologist to whom historians of anthropology have devoted most attention, recent work has shown that his work expresses merely a period of professionalisation of concepts that originated in the late eighteenth century as part of the Enlightenment endeavour to create some order in the growing body of data on peoples in the world of that era. At that time concepts of ethnography and ethnology were coined to represent a "science of nations and peoples" which, when established in ethnological societies (1834–1843) had already been given a different meaning. The insight that ethnography reaches back to particularly German Enlightenment thought of the years 1771–1787 challenges standard views according to which anthropology started as a discipline with either the foundation of ethnological societies or their academic institutionalisation by means of university chairs in the late nineteenth century and the beginning of the twentieth century.

3 See Arturo Roldan "Malinowski and the Origins of the Ethnographic Method," *Fieldwork and Fieldnotes,* Hans Vermeulen and Arturro Roldan, ed., London: Routledge, 1995.

4 A classic diary of this kind is that written by Malinowski, whose recent publication as *Malinowski Among the Magi*, London: Routledge, 1988, had a profound impact on the self-reflective anthropology of the 1990s.

5 Ginzburg, Carlo, "Clues: Morelli, Freud, and Sherlock Holmes," *The Sign of Three: Dupin, Holmes, Peirce,* Umberto Eco and Thomas A. Sebeok, eds., Indianapolis: Indiana University Press, 1983.

6 See Alfred Gell "Technology of Enchantment and the Enchantment of Technology," *Anthropology, Art and Aesthetics*, Jeremy Coote and Anthony Shelton, eds., Oxford: Oxford University Press, 1992.

7 Earlier installation of the same piece, *Recite Autobiographiques Suite Venitienne: le confessional,* 1991, ARC Musee d'Art Moderne de la Ville de Paris.

8 Gell, Alfred, *Art and Agency: An Anthropological Theory*, Oxford: Oxford University Press, 1998.

9 Strathern, Marilyn, *Property, Substance and Effect: Anthropological Essays on Persons and Things,* London: Athlone Press, 1999, pp. 62–69.

10 Strathern, *Property,* p. 68.

11 Mauss, Marcel, *The Gift; The Form and Reason for Exchange in Archaic Societies*, W.D. Halls, trans., London: Routledge, 1990.

12 Schrift, Alan, "Introduction," *The Logic of the Gift: Towards an Ethic of Generosity*, London: Routledge, 1997.

13 Cheal, David, *The Gift Economy,* London: Routledge, 1988, p. 19.

14 Strathern, "Partners and Consumers," p. 295.

15 Strathern, "Partners and Consumers," p. 303

16 See Marilyn Strathern, *The Gender of the Gift: Problems with Women and Problems with Society in Melanesia*, Los Angeles, CA: University of California Press, 1988.

17 Battaglia, Deborah, *On the Bones of the Serpent: Person, Memory and Nortality in Sabarl Island Society*, Chicago, IL: Chicago University Press, 1990, p. 191.

18 Strathern, *Gender*, p. 306.

de-, dis-, ex-.

…TUREL

NÔTRE

PAUL & VIRGINIE

…U

…ENTIER

…LIN D. ROOSEVELT

P. CLASTRES

SAINT-PHILIPPE-…

TIERRA INCOG…

MIROME…

LES…

⑯ Ⓐ

16 17

TAMANRASSET

③ CHÂTILLON RACISME TRANQUIL…
SAINT-DENIS · ASNIÈRES-GENNEVILLIE…

NOUVEAU MONDE
TERRE-NEUVE

CAYENNE

DU-ROULE

VITA

GEORGES
BATAI

SNIL

LEIADES

SAINT-AUGU

PIERO DELLA

HAV

LA

18 — 19

78

GALLIENI

3 GALLIENI
~~PONT DE LEVALLO~~

MODELL

RER

Scenes From a Group Show: Project Unité
Renée Green

Site: Firminy, France, Summer 1993. A semi-deserted
housing project which was designed by Le Corbusier,
one of his Unité Habitations. Artists and architects
from the US and Europe were invited to participate
in an exhibition in the deserted half of this
structure.

This Scene: 'Secret'

Producer and Director: Renée Green

Co-Producer: Yves Aupetitallot

Cast: Renée Green, Mark Dion, Tom Burr, Christian
Philip Müller (also actors in "What Happened to
the Institutional Critique?") and many others.

Synopsis: "Project Unité" was organized by Yves
Aupetitallot with the intention of "going beyond
the confines of art and culture."

Props: Four copies of Germinal, Secret (figure
drawings by Le Corbusier), Firminy files,
videotapes, monitor and VCR, box for James, book
layout, photos, journal pages, typing paper.

Giving Props To: Le Corbusier ('Corbu') without
whom none of this would have been possible, the
tenants of the Unité for enduring what was made
possible, Emile Zola for writing Germinal which
provided a reference point for the view beyond
the Unité balconies and as well as for the previous
socio-economic conditions of the region, however
fictional.

Character Profile: The character is visibly a female
with brown skin and dreadlocks. She was born in the
US and thus speaks English as her native tongue, but
she studied French and in brief exchanges can seem
to be from some French-speaking place. Where she
might be from is very dependent upon the language
she speaks. She's been asked at various times and in
various places whether she's from Martinique, Puerto
Rico, Guyana, Jamaica, some island near Venezuela,
Paris, and New York. She's been told by a Senegalese
that she resembles a girl he knew in Senegal and
by a Mexican that she looks just like his cousin.
She is from the metropolis, in her case New York.
 She has decided to visit a 'modernist utopia'
because she was invited and because she was curious
about what this could possibly be. She pitched her
tent inside of what is now a modernist ruin. Because
it was designed by Le Corbusier it is valued by
some, who never lived there, like a shrine, a
monument. It became part of the Corbu mythology
and is kept alive by those who want to keep alive
his precepts as they have interpreted them.
 But this place was also inhabited. To some degree
by people who weren't born in France, but are from
places where people speak French in Africa and in

the Caribbean, or who were children of people from these places. In addition, there are people who were born in France. The rent is cheap and appeals to people who may be unemployed, have part-time jobs or simply can't afford to own their own homes.

The character has decided to do fieldwork on herself in this place which was unfamiliar to her, but familiar to its remaining inhabitants. She considered it fieldwork because she was on an unfamiliar terrain, outside of the city, attempting to inhabit an uninhabited area of a monumental ruin where she was meant to stay alone. This fieldwork is on "the society (she) is condemned never to leave: (herself)." She will execute a self-styled auto-ethnography. If others enter her narrative space they too will be described.

She didn't think she would change the lives of the inhabitants during her short stay, nor did she imagine she could document their existence in anything more than a journalistic way. She'd already attempted to do social-service-related work in her own metropolis and realised how much time and devotion are necessary to make any meaningful connections, and that even then the effects can be other than hoped for, especially if one's hopes are projected onto others, rather than created through a mutually ignited dialogue. She recalled a quote by Albert Camus she'd read in Motion Sickness, by Lynne Tillman: "I realised that modesty helped me to shine, humility to conquer and virtue to oppress."

Because she doesn't want to appear hostile to social contact she will wear a uniform which alludes to her transient status, which she hopes will be read as a peace offering or as a joke for other Unité inhabitants. Some would understand. Everyday she would wear a quilted vest with the word immigration sewn to the back in big glow-in-the-dark letters. In French the word is the same and so is the meaning. One thing the character anticipated was

de-, dis-, ex-.

that she might encounter others who, like herself,
were products of the African diaspora. They would
have in common their skin colour which ranged the
various shades of brown. Even if culturally they
were different, at borders they were usually viewed
with suspicion.

The character left these traces: a journal, files,
some photos, videos and books in a box inscribed
"For James, good luck with your group show." She
also left instructions for the production of a book,
which like most of her works, is still in progress.
Where is she?

Firminy: The first 24 hours
I arrived in Firminy on Monday night. The day before
I'd flown from Vienna to Paris. I spent the night
in Paris in a very comfortable bed, with big fluffy
pillows. During Monday morning I walked all around
Paris. In a bookstore, which I'd visited before, I
found a copy of Germinal, by Emile Zola. I bought
this copy to supplement the English copy I already
had with me.

During the afternoon I went to the Gare de Lyon
and purchased my train ticket. Somehow, before
buying my ticket I got trapped in the banlieu
section of the station, and had to beg to be let
out. I'd bought some food from a boulangerie with
which I was familiar, and because I was pressed for
time I ate it standing up at a food stand in the
station.

After that I took a train to Odéon and walked
around St. Germain, which is where I bought the
book. From there I walked down Rue Bonaparte and
crossed the Seine at Pont Neuf, which is under
construction. My feet ached from walking and I
arrived early for an appointment at Café Beaubourg.

Getting all of the luggage on the train was a bit
of an ordeal, and I kept having flashbacks of
trying to move tons of luggage in the pouring rain

from a train station in Nantes two years ago. That
time I missed the train because it wasn't possible
to get a cart in time.

When I arrived in St. Etienne I somehow managed
to unload all of the luggage and slowly move it to
the door nearest the parking lot. Eventually, I was
picked up and assisted with the luggage.

We brought the luggage directly to the seventh
floor, to this space which I'm now inhabiting. It
seemed too jarring to immediately begin unpacking,
so I went to visit the model apartment.

There I was offered dinner. Since I'm allergic
to tomatoes I made my own sauce for the spaghetti,
which was probably my undoing. I used blue cheese,
butter and milk. As I ate it it seemed alright.
Perhaps it was the sandwich which I'd been carrying
around all day and finished eating on the train
which later made me feel so ill. I don't know
exactly what the cause was, but by 6am I'd begun
to feel extremely nauseous.

de-, dis-, ex-.

I returned to my quarters in the deserted part of
the seventh floor and noted what a strange situation
I was in. I was and am the only inhabitant of one
of these formerly deserted apartments. The hallway
is now filled with tools for construction, to make
an exhibition in the apartments. For me the
apartment is one more temporary place to live and
work. I've been transient for at least the last
year, staying for short periods of time in different
countries to work. In this case the work space,
living space and exhibition space are one.

Last night I was questioning the staunchness of
my empirical approach to this exhibition. For me
it seemed important to actually use the apartment as
an apartment, to the extent which that is possible.
Unfortunately, the toilets and water do not
function, which reflects a kind of camping or
squatter situation. Thus, I brought camping gear to

manage with. Unexpectedly, there is electricity, so I'm able to work late into the night, as I did last night, and as it seems I'll be doing again tonight. It is 1:30am. A very quiet time here. Now it is possible to imagine this space as a monk's cell, although I have more things than a monk would have.

Last night I set up the tent to sleep in and began making a videotape documenting my stay here. The tent seemed to provide some shelter for my first night here, its interior was a familiar one. The apartment itself seemed too alien to shelter me.

This day has been spent in a weird sort of stupor, largely the result of feeling so ill. I woke up at 6am and began videotaping. Then I tried to go back to sleep before the workers came in the morning at 8am to continue working on the exhibition. How artificial I thought, that because this is an exhibition workers will come and wake me up when I'm trying to live in this place. The birds began chirping very early and I heard the first motor in the parking lot rev up. It was very important to me to be able to be aware of the passing of time

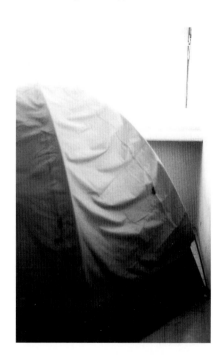

during the day, and to document different moments.
I kept trying to do the different activities I'd
planned, but with little success, because of this
illness. At some point I managed to get to the
model apartment to take a bath. Workers had already
been singing at the top of their lungs and had
already entered this apartment just seconds after
I'd gotten dressed. They didn't know I was trying
to live here. It was strange going past them and
all sorts of materials first thing in the morning.

After bathing I returned to this cell to attempt
to read, but the spasms I was having in my stomach
prevented that. I did manage to assemble a mirror.
I tried to take some polaroids, but they came out
quite strange, with parts of the emulsion ripped off
them. I showed them to Oliver, who said there is a
rumour that Corbusier's ghost inhabits this place.
Later, Uli saw the photos and said that she'd gotten
similar results trying to take polaroids here and
that it was uncanny.

I'm locked in here, but I just heard a sound.
I have the keys. Maybe I'll lock the apartment door.
I've locked the door, and I definitely heard a
noise outside resembling banging. In the distance
I hear dogs and crickets.

Maybe tomorrow I'll begin to enter some kind of
delusional state, because I haven't eaten in over
24 hours. I was repulsed by food today. I just
heard the banging again. This place has an eerie
quality, this unlived in area. It reminds me of
the big hotel that Jack Nicholson is supposed to be
the caretaker of in The Shining. There are traces
of previous inhabitants there, as there are here.
In the movie the rooms appeared emptied of all
previous traces, yet the psychic traces remain.
The Jack character, like myself, is trying to type
his way out of or into something. Tonight I have
one more piece of furniture, a mattress. Maybe
I'll be able to sleep.

Wednesday Morning: Firminy
The workers are in the hallway in full effect.
There are sounds of motors buzzing outside in the
distance. The morning began sunny, at around 8am,
but now at 9:30am it has become overcast. I've
begun videotaping today's activities, including the
typing I'm doing at this moment.

I feel much better. A mattress made all the
difference. I slept until the alarm went off at
8am. The sun was streaming in through the two storey
windows. I was facing the windows and all I can see
from them is the sky, when sitting or lying on the
mattress.

I hope the bread truck comes today. I saw it
yesterday from the terrace of the model apartment.
At that time I didn't have the strength to go
downstairs, nor could I really have eaten anything.
But today my stomach is growling from hunger.

This apartment is gradually beginning to look like

de-, dis-, ex-.

the cover of the book The Real Bohemia, on which
there is a mattress on the floor and probably a
typewriter similar to this, and some bongos. This
set up is very similar to the housing I lived in
during my second year in college. The college
housing was called 'the low rises' as opposed to
the nearby 'high rises.' I lived in a ten-person
low rise. These buildings were next to some housing
projects in Middletown, Connecticut, where those
people, the 'townies,' lived all the time, not just
for a year like us.

I always find it strange to return home to no
answering machine, even though I've gone for months
during the past year without one. The days seem very
long here. The sun is shining brightly at 8:15pm.

I realised, upon stepping outside, that I hadn't
been out of this building since Monday. I've been
on the terrace a lot. This morning I painted a
watercolour of the view. Yesterday, Stephan showed
me a video he'd made of some guys who are musicians

who live in the building. He asks one of them how
often he goes out, and his reply was: "Oh, once or
twice a month." When one musician is asked if he
misses having any bars or social gathering places
to go to he says no, because he meets people in
the hallway, or maybe he meets someone in town and
discovers that they too inhabit the Unité, and
they can simply ring each other up and visit.

I have noticed people are pretty friendly here.
Of course it helps if you can speak French. The
atmosphere here is pretty calm compared to housing
projects in New York. As I was on the terrace today
listening to krs 1 rap about the "South Bronx, the
South South Bronx," I imagined being in Co Op City,
but without a Bronx nearby. Co Op City, like here,
is pretty self-contained. This is even more so
because it doesn't contain a shopping mall.

I went for my first excursion in search of food
this evening. Not having eaten since Monday I was
ravenous.

de-, dis-, ex-.

Tonight there is no electricity, so I am prepared
with my American Camper flourescent lantern.
Lightning is flashing through the sky. Concrete and
sky are my view.
This is Wednesday night. I will have two or maybe
three more nights here. Two British architects asked
me what it was like to actually spend the night
here. One assumed it was in the nightmare variety
of experiences. Tonight the wind has been howling.
Doors kept slamming shut in the model apartment
because of sudden gusts of air. Living, working and
sleeping all blend together for me here. There are
few distractions.
I wonder where people do their laundry here. Today
my major discovery was how to take the path through
the woods onto a semi-highway to the supermarket.
Maybe tomorrow I'll learn where to do my laundry.
How does childhood figure in this work? Lord of
the Flies, Alice in Wonderland, Babes in Toyland,
The Wizard of Oz, Huckleberry Finn? Is there some
connection to what I'm doing in an abandoned half
of a building in Firminy? A desire for some kind of
strange exhilaration which comes from being lost?

Night Four: Firminy
It's funny how I'm actually getting adjusted to this
place. I'm extremely tired right now. I waver
between feeling like I've been in this apartment too
long and that I'm drifting off into a calm stupor.
What will it be like when I get the video monitor?
Part of what is so easy to deal with here is the
lack of outside conflict. People in the elevators
normally greet each other, and the attitude is calm.
Of course I'm comparing it to New York where tension
is constant. I am cut off from many things, similar
to being in a monastery cell.
Today was strange because I began the first six
hours in a very productive way, from 6am to noon,
but after that I had a lot of distractions. Again I

didn't get done a fraction of what I set out to do.

Last night I had difficulty sleeping because there was a powerful storm. I slid deeper and deeper into my sleeping bag because the lightning was flashing so brightly. I always have a fear that it will get inside and electrocute me. I kept waking up and checking to make sure that no electrical attractors were near me.

I think no one who knows I have this much paper believes I'll really use it all. They probably imagine it's just an artistic prop, more rubbish.

I'm so happy that my load will, literally, be lighter when I leave.

This project isn't really solipsistic. Would I be committing a crime if it were? The whole notion of solitary contemplation, or meditating on the place in which a group show occurs or on why a group show is made goes against the usual concept of group shows. This week I did manage to attain a state of deep reflection, which was a goal. The wallpaper is like some trance-inducing device.

de-, dis-, ex-.

Friday Morning, Day 5: Firminy
5:40am. As I was walking down the hall with the
keys I need to open the various doors to get to the
toilet, I had a flashback to when I was a security
guard in college. I worked the night shift, midnight
till 8am. On the hour I'd have to make my rounds
through various campus buildings to check that doors
had been locked. For a moment I couldn't remember
whether I'd had to wear an item of clothing with
the word security written in bold letters across
my back, similar to the vest I've been wearing all
week which says immigration. At first no one said
anything about this vest. Then one day one of the
students pointed to the word on my vest and chuckled
knowingly. She looks as if she might be part North
African. After that I noticed a group of North
African men, I'm guessing, their complexions ranged
from deep brown to swarthy, they could have been
from Martinique, I could have been from Martinique,
at any rate they were looking at me curiously, but
I didn't get a chance to exchange more than glances

with them because I was talking to Oliver. People
normally speak to me as if I'm from some French-
speaking place. The airline stewardess on the plane
from Vienna to Paris chatted with me throughout the
flight in French. Often I think of Frantz Fanon.
This place would be confining if used as intended.
Maybe it is best for a visitor. Maybe I can stand
all the dirt and dust because I lived in a loft for
a long time, which was like a squat.

Saturday Morning, Day 6: Firminy
Every morning the sun comes in so harshly. An
unrelenting wall of glass. You don't necessarily
want to see that much of the outside every morning.
Sleeping in the tent in the morning at least
eliminates some of the aggressiveness of the sun.
It's like being forced to wake up no later than 8am
every morning. Workers are supposed to get up early
every morning, was that the idea? What about people
with irregular hours, irregular jobs?

I feel cranky having been up late and now having
to wake up to this sun. The sun usually comes
piercing in every morning and then in several hours
the sky is grey. The thought of the art world
converging on this place is also irritating. I know
I'm part of it. But I haven't been pretending to
live here during this past week, I have been living
here and that puts you in a state of mind peculiar
to this place. It goes beyond the first initial
days of complaining about the conditions, the
dullness of the town, the distance of the
supermarket by foot. You begin to focus more and
more on what you need to get done and how to live
despite these circumstances. People live here, but
in a sense this building is like a way station.
Most of the inhabitants are relatively young. I say
it is like a way station, and for me like a hotel,
because it isn't the kind of apartment you would
pass down to your next generation. It was meant from
its inception to last one hundred years. A very
modern idea. How many buildings actually do last
more than one hundred years? It isn't so much a
question of whether structures are still standing,
but rather the rate at which they deteriorate while
people are still inhabiting them, and whether the
maintenance of a continually decaying structure is
beyond the tenants' means.

This place is constantly crumbling. The ceilings
are cracked and seem to be sloping down. Big slabs
of concrete resemble the continual road construction
in Brooklyn under the BQE. I got a lecture from a
taxi driver about the construction of the highways
as we slowly wheeled toward JFK airport almost three
weeks ago. He'd been in construction work before
retiring to drive a taxi. He kept pointing overhead
and around and kept saying, "Why? Why this structure
here? It won't alter the flow of the traffic." One
can wonder the same thing about this Unité. Half of
it is shut. This area doesn't have an excess

population. There aren't jobs here. But this is an architectural monument.

I keep thinking, what kind of people were imagined by Le Corbusier to live here? People with disciplinary standards similar to his own and who didn't require much in the way of comfort? He never wanted children himself. They would interfere with his professional life, he imagined. A compartmentalised life, each part with its purpose. Some of it secret, exposed partially in his private drawings.

There is no room for idleness here. The bathtub is small and the lighting, the original fixtures anyway, are too dim to be able to see your reflection well or to read while bathing. The toilet is utilitarian with no ventilating fan and no compensation for an obese person. Funny that the figures he drew, who were mostly women, were all huge. It seems hard to imagine them fitting into one of his toilets or bathtubs.

de-, dis-, ex-.

The morning is ticking away, my last morning here.
More and more people will be arriving to adjust
things and to see things. Any peace I might have
gained will soon be finished. I'll be travelling
again, for weeks.

Yesterday I had an especially nerve-racking hour,
during which I couldn't locate my keys. Actually,
the way that locating process was handled makes me
bristle even now. I hadn't wanted to leave my
apartment, but because this is an art exhibition and
not simply a free living arrangement I had to try
to get reimbursed for my expenses before it was too
late. In the hallway there was a flurry of
activity. Stephan mentioned that he'd seen Yves in
the hallway and that I should approach him directly.
That's when I shut the door with the keys inside,
and for the first time all week it locked, but I
didn't know that. I began meeting other artists and
people I hadn't seen in a while. I went to the

office to try to get paid, but no one was there who
could help me, just more artists hanging out. Then I
realised that I didn't have my key.

For me this was a complete trauma, especially
given the timing. To be wandering around in these
hallways with no access to a private place amidst
pre-opening frenzy was anathema to my reason for
even being here. Eventually, some workmen helped
me, but not without trying to make me feel like
a stupid female. "Stupid, silly little woman,
you're in the way while we're trying to work on
big important art works made out of materials
which are heavy or difficult, or...."
At, least this was the way I felt, and at that
moment I thought, "Just fucking pay me." At the
moment, until I get paid, this remains a very
costly week of everyday life.

Afterwords

Many people came to the exhibition at the Unité
in Firminy. Many words were shed there and later
in the media.

At the opening the inhabitants of the Unité and
the artists exhibiting in the former habitations
were all invited to a party in the social space on
the top floor of the building. The food seemed to
have been imported from any number of delis you
might pass or enter in New York's garment district.
Huge vats of mayonnaise covered salads and cold cuts
were brought forth. This was not the France of the
baguette and brie.

There was a palpable tension in the air. The
artists stayed in groups with other artists and
art world infra-structural personnel, the tenants
stayed in groups with their friends and neighbours.
No speech was made. What could have been said?
Maybe a speech had been made.

A fight began. An inebriated male tenant began

throwing punches in all directions. All were
forbidden to leave the floor until the man could be
stilled. Eventually, bruised and bloody, he left.
Everyone else was also free to leave.

Closing Quote
"When the typewriter was invented, typing paper
was standardised; this standardisation had a
considerable repercussion on furniture, it
established a module, that of the commercial
format... this format was not an arbitrary measure.
Later, one appreciated its wisdom (the
anthropocentric measure) which it established. In
all objects of universal usage, individual fantasy
recedes in front of the human fact." (l.c.)

Fin.

URUKU

S-NOIRS

ROSA LUXEMBURG

PETRARCA

TABLEAUX

JOT

ONTMARTRE

WALTER BENJAMIN

BONNE NOUVELLE

STRASBOUR

CHE

RÉP

LE

33 169cm

23

24

25

1 0

23

24

GNANCOURT — PORTE D'ORLÉANS

FEIL FANTÔME AFRIQUE

IRS MANOA

EL DORADO

③ GALLIENI

⑤ BOBIGNY

⑧ BALARD

⑪ MAIRIE D

OUIDAH

SAINT-DENIS

G FORSTER

RACISME

TORTURE

LIQUE

ANTAGRUEL

OBERKAMPF

MIC MAC

C.N. LEDO

SAINT

26

27

BOBIGNY
PLACE D'ITALIE

DE LEVALLOIS OUTRE-MER

CE D'ITALIE DJIBO

E FANTÔME AFRIQUE

AS-CHÂTELET - TOMBOUCTOU

DJI

Anthropology at the Origins of Art History
Matthew Rampley

The Ethnographic Turn

A recurrent motif of 1980s theorising about art theoretical discourse
was the idea that art history had in some sense come to an end.
Common to a wide range of authors, from Donald Preziosi, to Victor
Burgin or Hans Belting was a sense that the discipline, as traditionally
conceived, was in a state of crisis.[1] The motivations for such
judgments were various. One important cause for this sense of the
disintegration of the discipline was the impact of conceptual and
methodological concerns of neighbouring subjects such as
psychoanalysis, sociology, literary theory and anthropology. As the
boundaries separating the different fields of the humanities began to
dissolve, so the identity of art history became destabilised, producing a
period of intensive reflection on its origins and history.[2] In addition,
the sense of crisis paralleled the wider pronouncements of the time
concerning the death of art.[3] At a time when the legacy of, amongst
others, Hans Haacke, Marcel Broodthaers or Art & Language entailed
that 'art' often seemed indistinguishable from museological critique,

de-, dis-, ex-.

sociological observation or philosophical analysis, it seemed impossible for art history to continue unperturbed in the face of the disappearance of its traditional object.

Within this general displacement of boundaries and practices, a shift of equal significance could be seen in what Hal Foster has described as the 'ethnographic turn' in art and art-theoretical discourse.[4] Foster's use of the term 'ethnographic' is somewhat loose, for he does not imply the entire edifice of institutionalised ethnography, but rather a privileging of cultural alterity. Of course, it would be misleading to claim that an attention to alterity, to the marginal and the excluded has hitherto been alien to art history. One of the 'founding fathers' of the subject, Alois Riegl, built up his reputation on his study both of marginal artistic forms such as rugs, buckles or fibulae and of neglected epochs in the history of art.[5] Furthermore, it would be impossible to ignore the well-established tradition of Marxist art history, which, in addition to analysing the conditions of artistic production also frequently attended to the art of marginalised groups. However, for figures such as Riegl, the excluded still tended to sit within the mainstream of European culture, and because Marxist art history (and much avant-garde art practice) had viewed culture primarily through the paradigm of production, marginal groups were mostly conceived of as such in economic terms only. In a post-industrial and post-colonial era, however, the focus of such conceptions of alterity has shifted and now approaches the other in terms of general cultural difference, manifest through, for example, gender identity, ethnic affiliation, or sexual orientation. The heterogeneous basis of such alterity is intimately linked with the rise of a general cultural semiology in which the traditional anthropological concern with the primitive 'other' has expanded into an all-embracing ethnography of otherness. Art history thus becomes an investigation into visual representations *per se*, and a recent anthology of essays on visual culture can include studies of the painter Robert Ryman, the rhetoric of cigarette advertising, television and the cityscape of London's East End.[6]

While such a blurring of disciplinary boundaries is the result of a quite specific constellation of events and processes, both internal and external to the history of the disciplines in question, it is important to note that there is a deeper historical dimension to the 'ethnographic turn,' and this is related to the legacy of the concern of Western culture with the primitive. In particular, a fundamental preoccupation of Enlightenment thought – indeed of modern culture in general – has been the search for origins. From Willhelm von Humboldt's work on the origin of languages to Darwin's speculation on the origin of species, and from Nietzsche's investigation into the genealogy of Western philosophical and ethical values to Freud's archaeology of the primal strata of the self, much of the logic of the philosophical, historical and natural-historical discourses of Western modernity was organised around a concern with the archaeology of human historical and natural-historical existence.[7] It might even be possible to employ such a concern with beginnings to map out the path of Enlightenment culture, its starting point being the publication in 1725 of the first edition of Vico's *New Science* and its end marked by the appearance of Theodor Adorno and Max Horkheimer's *Dialectic of Enlightenment* in 1944.[8] The former constituted the first systematic account of the cultural logic of human historical development while the latter text turned such historical-theoretical concerns into a reflexive analysis of the emergence of Enlightenment itself.

Within this paradigm equal attention was paid to the origin, history and function of art and aesthetic experience. Arguably, the emergence of the self-consciousness of modernity itself can be traced to the so-called *Quarrel of the Ancients and the Moderns* of late seventeenth century France – debates over the historicity of art (and culture) and the normative status of the legacy of classical art, which anticipated the philosophies of history of the following century. In this regard it is important to take note of Jürgen Habermas' assertion that a fundamental determinant of modern culture was an altered perception of the meaning of time and history, to which a transformed

de-, dis-, ex-.

consciousness of the temporality of art made no small contribution.[9] This aesthetic inflection of the Enlightenment discourse of origins revolved around the central question of the relation between the fundamental principles of aesthetic experience and the historical process of human cognitive and cultural development. Crucially, for this essay, the intersection of these two paths – the aesthetic and the historical – formed the necessary condition for the emergence of the discipline of art history, as opposed to a concern with the development of technique (Vasari) or a concern with the moral purpose of art and its hierarchy of forms. In addition, while the narrative of Western art history was primarily focused on a Eurocentric artistic lineage from Ancient Egypt to modern France via Greece, Rome, medieval Europe and the Italian Renaissance, it was speculation on the 'art' of so-called primitives that helped construct a matrix within which the identity of Western art was established. In the late nineteenth and early twentieth centuries, as the discursive formation of art history was beginning to establish its contours, there was a proliferation of speculation on the origins of art, in which a generation of scholars attempted to accommodate art historical concerns with the insights of anthropology. Such attempts were eventually displaced by interest in questions of attribution, patronage and iconological interpretation, and restriction of interest to the history of Western art. But this process is a very recent one, and while the death of art history has been heralded for the last twenty or so years, the form of art history that has subsequently been dismantled was actually rather short-lived.[10] This essay is concerned with revisiting the historical antecedents of the ethnographic turn in order to retrieve a period in which disciplinary boundaries were fluid *because they had not yet been formed.*

Formal Principles

Although largely a philosophical discourse on the fundamental principles of aesthetic experience, Kant's *Critique of Judgment* is

den gewobenen den ausschliesslichen Vor-
zug, dass die Fadenelemente, woraus sie
bestehen, sich nicht nothwendig alle senk-
recht durchkreuzen müssen, wie diess die
Weberei bedingt, sondern dass auch dia-
gonale und nach allen Richtungen lau-

commonly regarded as the point of origin of modern art theory.
Central to Kant's notion of aesthetic experience is the exercise of
creative fantasy in which the free play of imagination and
understanding results in a game of identification and misidentification,
a semantic ambiguity that for Kant produces an "aesthetic universal
delight."[11] Although this "quickening of [the] cognitive powers" as
Kant terms it, is a subjective experience theoretically applicable to
any phenomenon, it comes to be objectified in natural phenomena
or works of art, and in both cases the proper focus of aesthetic
contemplation is an object's formal characteristics. Hence,
in art, colour is secondary to the formal design, and ornament is
dismissed as being external to the intrinsic unity of the work; it is
"only an adjunct."[12] This dismissing of ornament is of no small
significance. Since Derrida's critique of the distinction between 'work'
and the 'parergon' it has become a near commonplace to maintain
that ornament functions as a supplement: an extrinsic element that
makes good a lack in the work itself.[13] While, for Kant, ornamentation
is "not an intrinsic constituent" of the representation, *purely* external
ornament, such as the gold frame of the painting, detracts from its
beauty. The parergon is both in and outside the work. This is also true
of his comments on colour, for while design is central and colour
parergonal, the latter helps "make this form more clearly, definitely
and completely intuitable."[14] Formal design, as the *proper* object of
aesthetic judgment, is dependent on what Kant elsewhere relegates to
the realm of the merely charming.

Illustration from Gottfried Semper's *Style,* of the decorative
patterns formed by the techniques of weaving in Ancient Egypt.
All images courtesy of the Warburg Institute.

The contradictions of the parergon are of wider significance, for they highlight a general feature in much art theory of the nineteenth century.[15] While the decorative arts were regarded as secondary to the high arts of painting and sculpture, ornamentation came to occupy an essential place in the conception of art and aesthetic experience, and most particularly in terms of the discussion of the origins of art. Indeed, it becomes a defining feature of human beings *per se*. Thus, for Friedrich Schiller, one of the "visible signs of the savage's entry into humanity" consists in a "propensity to ornamentation and play."[16] Likewise, Hegel's *Lectures on Aesthetics* treat ornament, and the arabesque in particular, as an essential mediating link between organic form and rational construction.[17] Specifically, the transition from the rigid geometries of the architecture of pre-classical, symbolic art (the crystalline forms of the pyramid) to the temples of classical Greece is encapsulated in organic ornament (palmette and acanthus leaf decoration), which mediates between nature and culture. Again the logic of the supplement is apparent here: ornament, normally considered a secondary aspect of the work, becomes central to the development of classic art which, in Hegel's schema, constitutes the highest art form. Hegel's interpretation of the meaning of the arabesque in architecture was repeated by the architectural historian Carl Boetticher, whose *Tectonics of the Greeks* of 1849–1852 again saw ornament as a structural element mediating between the formal and functional bases of architecture.[18]

From the middle of the nineteenth century onwards there was a proliferation of works on the meaning of ornamentation. Though often produced as a polemical response to the onset of mechanisation, such works also carried forward aesthetic preoccupations from the last decades of the previous century. In this context one has also to take into account the continued importance of formalism, which, from the 1850s onwards, again became central to the understanding of art, through the publication of works such as Eduard Hanslick's *On the Beautiful in Music* or Karl Rosenkranz's *Aesthetics of Ugliness* (both

appearing in 1854) or, in the following decade, Robert Zimmermann's influential *General Aesthetics as the Science of Form.*[19] With regard to the question of ornament two writers are of particular interest: Gottfried Semper and Owen Jones.

Apart from his work as an architect, Semper is best known as the key figure in the development of a materialist aesthetics.[20] In books such as *The Four Elements of Architecture* and *Style in the Technical and Tectonic Arts*, Semper developed a theory of art that emphasised the primacy of the functional basis of the arts; all aesthetic and stylistic aspects were a symbolic reflex of originally practical demands. Thus whereas Schiller had referred to a primal impulse to ornamentation, Semper located the origins of ornament in the patterns produced by the fibres of woven textiles. Such patterns, originally a consequence of the technique of construction, then came to be transferred to works in other media, their former functional basis eventually being forgotten. This is not to imply that formal considerations were somehow purely extrinsic to the work, but in emphasising that such concerns were generated through working with the materials and techniques necessary for the production of the work in question, Semper was reversing the priorities established by the formalist tradition. And yet while Semper posits a material origin for ornamentation, he also regards it as the primary manifestation of an aesthetic sensibility. He even comes to write of a 'decorative impulse' ('Schmucktrieb'). In a lecture specifically devoted to the question of ornament, Semper regards ornament as a symbolic ordering of the world and thus as the expression of a primal impulse of all humans: the need to control and understand reality.[21] Hence, while Semper's account of the origins of ornamentation takes issue with the formalism prevalent amongst many contemporaries, he is united with them in the acceptance that it is the originary aesthetic activity.

Owen Jones' *The Grammar of Ornament* was conceived of less as a theoretical account of the meaning of aesthetic form and more as a polemic against the degradation of design quality through the

introduction of machine manufacture. In this it therefore paralleled similar critiques formulated by Augustus Pugin and John Ruskin or William Morris, and indeed Jones' introductory text adds little to existing views on the subject.[22] Jones typifies the modernist concern with origins and first principles; he prefaces the work with thirty seven "General Principles in the Arrangement of Form and Colour." Of perhaps greater significance is the fact that whereas the cultural norm had usually been provided by classical Greece, Jones regarded the most accomplished form of ornamentation in the ornament of 'savage tribes,' namely, the facial tattoos of the New Zealand Maoris. As he notes, "the ornament of a savage tribe being the result of a natural instinct is always true to its purpose, whilst... much of the ornament of civilised nations... is oftentimes misapplied... all beauty is destroyed.... If we would return to a more healthy condition, we must even be as little children or as savages."[23] Jones is drawing on the well established philosopheme of the noble savage, but whereas this had been common currency since Rousseau, the specific notion that contemporary artists had something to learn from the decorative art of the 'primitives' was quite novel. Although he was not consciously attempting to reframe the discussion of aesthetic form, his *Grammar* serves to unite the question of ornament with an anthropological interest in the natives of the various European colonies. Origins were no longer sought in Greece, Rome or Egypt, but amongst the aboriginal inhabitants of sub-Saharan Africa, South America or the South Pacific. Of course, writers prior to Jones were not unaware of such cultures – Semper includes mention of New Caledonia and the Indians of North America, for example – but the principle point of focus in terms of origins was the classical cultures of the Old World. Thus Symbolic art, for example, the earliest stage of art in Hegel's *Aesthetics*, found expression in Zoroastrian Persia, Ancient Egypt or India. And while in his philosophy of religion Hegel places 'primitive' phenomena such as Mongolian shamanism or Inuit and African magic religions in the logical unfolding of religion, no parallel place is accorded the art of such cultures.[24]

An indication of the shift that occurred in the latter part of the nineteenth century is provided by the manner in which Alois Riegl's *Problems of Style* critiques Semper and the materialist understanding of art.[25] Taking issue with the Semperian view of ornament as a secondary reflex of practical and technical processes, Riegl argues instead for the primordiality of a formal impulse to ornamentation, motivated by a *horror vacui*: "the need for decoration is one of the most elementary human needs, more elementary than the need to protect the body."[26] And Riegl states in a separate essay, too, "We know of savages who scorn every form of clothing, but who cover the entire surface of their skin with tattoos... even today we come across this artistic *horror vacui* that cannot tolerate any empty spaces."[27] The reference to the body is important here, for in *Problems of Style* Riegl bases his argument on the observation that the most primitive form of aesthetic expression is the tattoo: "far more elementary than the human need for bodily protection through textiles is the need to decorate the body."[28] Formal decoration of the body is primary, and Riegl uses this notion on which to base a claim for the primacy of plastic over pictorial representation; as he notes, "it has often been reported by travellers that Hottentots and the aborigines of Australia cannot recognise a drawing or photograph of themselves: they can only grasp things... corporeally."[29]

Riegl's primary source of evidence is thus no longer classical art but rather the products of the 'primitive' peoples of Africa and the Pacific,

Illustration of Maori facial tattoos
from Alois Riegl's *Problems of Style.*

and this in a book devoted to the development of ornamental motifs in the classic 'Old World' cultures of Greece, Rome, India, China and the Islamic Middle East. The ethnographic flavour of Riegl's reference to the Hottentots is developed at greater length a few pages later in the Introduction in which Riegl uncritically adopts a standard motif of anthropological thinking of the time. Here he argues

> Since we can consider ourselves as 'justified,' in the modern scientific meaning of the word, to regard primitive peoples as the rudimentary remnants of long gone cultures of the human race, it appears that geometric ornament, when viewed in this light, is likewise a long superseded phase in the development of the decorative arts, and for this reason of great historical significance.[30]

In other words, today's 'primitives' are a historical relic – a recurrent anthropological term was 'survival' – and thereby offer information about the origins of European civilisation. Hence the practice of ornamental tattooing, widespread amongst primitive cultures, gives an indication of the origins of Western art. The fact that this form of thinking involves huge logical leaps hardly needs stating, but it was nevertheless a commonplace of nineteenth-century anthropology and not only provided the rationale for scholarly attention to 'primitives' but also informed debates in other areas, such as the development of architectural modernism. For example, Adolf Loos' celebrated invective against ornament, though partly motivated by a desire to repudiate the eclecticism of late nineteenth century architecture, was also based on a more general view of human development in which "the evolution of culture is synonymous with the removal of ornament."[31]

Riegl's *Problems of Style* is generally regarded as a key work of formalist art history and theory, and yet a central part of his theoretical position is based on thought drawn from contemporary anthropological research. Implicit in his account is a notion of cultural psychology which would be made explicit in later works such as *The*

Late Roman Art Industry through the axiomatic concept of the 'Kunstwollen' or 'art drive.' Considered in this light, Riegl's employment of the concept of the collective 'Kunstwollen' can be compared with the more general concept of the group mentality or 'Volksgeist' of Willhelm von Humboldt which would be highly influential on German anthropology of the nineteenth century, and with this it is appropriate to turn to anthropological discourse and the role of cultural history.[32]

Primitive Origins

I have already noted that much of the critical investigation of aesthetic origins assumed that classical culture provided the aesthetic norm. Notions of beauty were based on readings of Greek and Roman art. Only in the second half of the nineteenth century was this paradigm displaced by recognition of the much more distant origins of human culture, of which the 'primitives' of Africa, Oceania and America constituted a continuing reminder. In fact the roots of such awareness can be traced back much further. As Anthony Pagden has suggested, the beginnings of comparative ethnology can be located in debates circulating in mid-sixteenth century Spain over the legal status and classification of the American Indians.[33] Of central significance were works such as the *Apologética Historia* of Bartolomé de las Casas or José de Acosta's *Historia Natural y Moral de las Indias* of 1590, both of which attempted to counter contemporary views of the Indians as simple savages or barbarians by emphasising their intrinsic humanity.

This is not the place to give a full account of the origins and history of anthropology, comparative ethnology and the interest in 'primitive' culture; in any case there were arguably many origins, from Lafitau's *Customs of the American Savages Compared with the Customs of Earliest Times* published one year before Vico's *New Science*, to Rousseau's speculations on the origin of social justice, Herder's writing on the specificity of cultural values, or Henry Maine's work on primitive legal customs.[34] Moreover, while many of the concerns of

de-, dis-, ex-.

anthropology were anticipated in debates dating back to the Renaissance, it is only in the nineteenth century that anthropology emerged as a self-conscious discursive formation separate from the philosophy of history or natural history, a formation that, through the establishment of scholarly societies and academic institutions, gained concrete form as a distinctive field of knowledge. Instead my primary focus is the various interpretations of the *meaning* of primitive culture. Recent accounts have tended to emphasise the impact of Darwinism on debates concerning the relation between primitive and modern societies. Thus, a central topic of fierce argument was the appropriateness of using Darwinian notions of evolution as a means of theorising the process of development from 'primitive' to modern. However, such conflicting explanations of the mechanism of cultural development are of less relevance here than the question as to what made primitives 'primitive.' Two main strands of thinking emerged to explain the character of primitive man. The first was to view primitives as standing at the early stages of the cognitive (and hence moral) evolution of man. According to Herbert Spencer, for example, primitives had not yet developed the capacity for reflective thought, and acted instinctually. Such a disposition hindered any self-restraint – hence their moral degeneracy – and while primitives had a heightened perceptual acuity, they remained immersed in the mass of details, unable to overcome concrete particulars and formulate abstract generalisations.[35] At times Spencer even regards such cognitive 'under-development' as symptomatic of biological deficiency: the impeded development of the nervous system.

The second kind of account of primitive man regarded him as beset by fallacious reasoning. Primitive man was thus guided by an erroneous metaphysics, but at the same time was still capable *in theory* of the same reasoning processes as modern individuals. Edward Tylor's *Primitive Culture*, for example, explained the worship of ancestors and animistic religion as the result of a perfectly rational line of reasoning whose major error was a false set of suppositions – namely

that dreams were as real as the experiences of waking consciousness.[36] Equally, the belief in magic stemmed from a conflation of real and imaginary connections. For Tylor, then, primitive 'culture' was the manifestation of an underdeveloped and erroneous form of reasoning, and consequently cultural progress was attained through a process of correction of such false premises. One can discern here the echo of philosophers such as Hegel, whose philosophy of history was predicated on the view of the social *Geist* as the macrocosm of individual cognitive development. As with Tylor, cognitive evolution occurs through a process of logical reflection and refinement.

While Tylor subscribed to a form of evolutionary thinking – though not as crude as Spencer's – implicit in his account was also the notion that the distance between the 'primitive' and modern man was not one of *kind*, but that essentially they were the same. Given the events that occurred subsequently, it is ironic that in the nineteenth century it was in Germany that such a view enjoyed strongest support. Many of the founding figures of modern anthropology, such as Rudolf Virchow, Adolf Bastian or Franz Boas subscribed to such a 'monogenist' view of the relation between primitive and modern man, with a concomitant suspicion of evolutionary theory.[37] In his 1860 study *Man in History* Adolf Bastian stresses the importance of environmental factors for cultural development, and although he analyses the cognitive changes leading from primitive to modern man, the heart of his work is formed around the notion that beneath surface cultural differences all human beings are essentially the same, their thinking organised around certain "elementary thoughts."[38] Concerned with cultures as a whole, Bastian also coined the notion of the 'Völkergedanke,' a difficult term to translate, but one which implies that such elementary thoughts were shared and collective. A similar account was proposed by Willhelm Wundt in his vast multi-volume *Collective Psychology*.[39] Although critical of Tylor's branding of primitive man as a faulty logician, Wundt, a pioneer of clinical psychology, nevertheless accounted for primitive culture by reference to basic constituents of

de-, dis-, ex-.

LAOCOON

human consciousness, positing, for example, a notion of 'mythic apperception' by analogy with Kant's idea of transcendental apperception, and emphasising the role of fantasy and the imagination in mythology and primitive religions.[40]

Anthropology and Art History
From the congeries of ideas outlined above various attempts emerged in the late nineteenth century to combine aesthetic interest in the origins of art with the anthropological interest in primitive culture.

Laocoon Group, sixteenth century engraving.

Indeed, an engagement with anthropological theories of the primitive came to be seen as the prolegomenon to any account of the history of art. As Ernst Grosse asserted in his study *The Origins of Art*, for example, "One has to learn the times table before one can solve more advanced problems of mathematics. And for this reason the most immediate and pressing task for the social history of art is the investigation of primitive art...."[41] Such a view was stated most forcefully by August Schmarsow in his extended article on "Art History and Collective Psychology," which regarded Wundt's concept of collective psychology as the means of mediating between art history and anthropology.[42]

Wundt himself devoted a volume of *Collective Psychology* to the question of art.[43] As in his account of myth and religion, a central role is accorded to fantasy which, Wundt states, consists of an intensification of basic cognitive states; "the particular nature of fantasy... can be traced back to three principal activities of consciousness... (I) animating apperception... namely, the capacity of the observer to project themselves into an object... (II) the capacity for assimilation and the intensification of emotions... (III) the ability of consciousness to exercise its autonomous powers through shaping the objects of perception."[44] In this taxonomy of forms of projection, Wundt is also informed by the empathy theory of Robert Vischer, which was highly influential during the period in question.[45]

As an example of such primal capacities Wundt analyses children's drawings, in particular, the tendency of children to 'remould' reality in drawings and also to project themselves into the drawings. This free play of fantasy "is here the source of all practical activity. Plans, drafts, preliminary intentions are modifications of the same free activity of fantasy...."[46] Drawing on an analogy that would enjoy wide currency in the twentieth century, Wundt compares children's drawings with primitive art, specifically through their schematic use of form, their restricted vocabulary of motifs and simplified representational forms. Ornamentation is prominent in the discussion;

de-, dis-, ex-.

although it is no longer the earliest art form, it still constitutes an early stage in the evolution of art, and is linked to the primitive tendency to assimilation, an empathy with pure forms on the part of the spectator. It is noteworthy that while Vischer's essay on empathy stressed the constitutive role of empathy in aesthetic experience *per se*, it became historicised, in the hands of Wundt and others, into a definitive aspect of primitive experience – a procedure made all the more possible by its similarity to, for example, Spencer's observation that 'primitives' remained absorbed in details and were unable to form abstract generalisations.[47]

Schmarsow adopts Wundt's account unquestioningly, although he uses a different vocabulary. Now, instead of assimilation or projection he refers to the primacy of the haptic, a term borrowed from Riegl, and whose corporeal orientation also recalls the interest in tattoos as the earliest expression of an aesthetic sense. Quoting from Wundt, Schmarsow argues that the origin of all art is unmediated corporeal expression – the language of gesture – and consequently, "the transition from touch to vision and hearing remains a watershed of decisive importance for the artistic engagement with the world," inasmuch as art then becomes a vehicle of symbolic representation.[48] In his much longer study *Basic Concepts of Art History* Schmarsow puts forward a similar account; "We recognise… the basis of ornament to be mimetic behaviour…. And yet especially in the transition to a higher intellectual level, from the tactile values of the body to those of vision, from the things themselves to the image of them… one must not forget those unmediated emissaries of the inner life…. The stone statue of God communicates the warm feelings of the living worshipper through expressive movements and the language of gesture."[49] In this atavistic image of art, as both superseding primitive forms of aesthetic expression and also preserving the inheritance of a distant primitive past one sees a direct parallel with the anthropological interest in distant origins and the primitive survivals of today. While the arguments of Wundt, Schmarsow and others are often highly

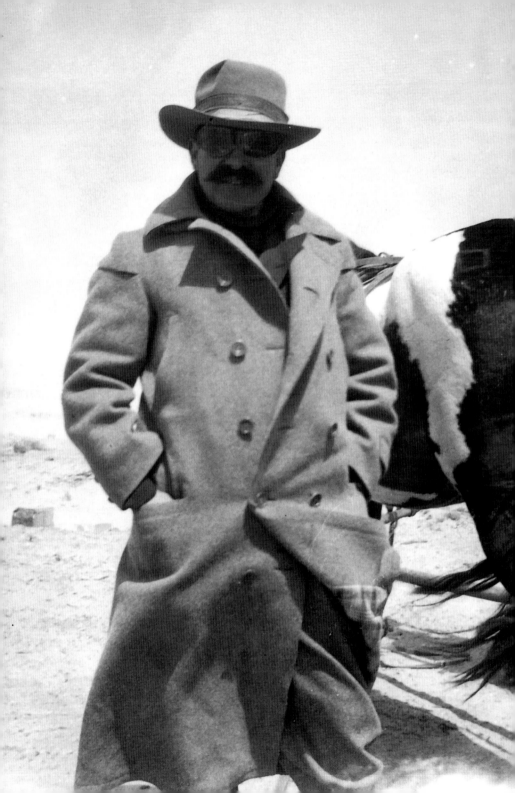

speculative and problematic, their interest in collective psychology, and their attempt to combine art history with anthropology, was shared by possibly the two most important art historians of their generation: Aby Warburg and Heinrich Wölfflin.

Aby Warburg is best known for his role as one of the founding fathers in art history of iconology, particularly in the study of the Renaissance. However, from the present perspective perhaps his most original contribution was the attempt to view the Renaissance through the lens of the anthropologist. Whereas contemporary views of the Renaissance tended to celebrate it as the conquest of modern humanism over the superstitious Middle Ages – a view informed by Jakob Burckhardt's *Civilisation of the Renaissance* – Warburg regarded it as a much more ambiguous phenomenon, constituted by the resurrection of European culture's own primitive past, namely, classical antiquity. Relying on notions of collective primitive psychology drawn from Bastian, Wundt and Richard Semon, Warburg saw classical antiquity as faced with exactly the same cultural-psychological problematic as the 'primitives' of the present day: specifically, a tendency to irrational immersion in the natural world, which constantly hindered the process of cultural development predicated on a fundamental 'splitting' of subject and world.[50] For Warburg this drama of acculturation and regression was played out over and over through human history, and was manifest in a variety of cultural forms such as myth, philosophy, or astrology, though his own interest was in visual representations. Thus he could compare such diverse phenomena as the snake dance of the Pueblo Indians of Nevada with the classical myths of Asclepius or Laocoon, on the assumption that they were symbolic expressions of the same problematic.[51]

Heinrich Wölfflin is more usually associated with the establishment of formalism within art history, his *Basic Principles of Art History* being a seminal text in this regard. However, as Frederick Schwartz has recently argued, Wölfflin's better known formalist writings were a

Aby Warburg, Arizona, 1896.

somewhat later development prompted, in part, by disaffection with the fluidity of contemporary fashion.[52] In contrast, his earliest substantial work, *Prolegomena to a Psychology of Architecture* attempts to analyse a visual style not through analysis of its formal attributes, but by reference to the fundamental collective psychology underpinning it.[53] Although this work does not share Warburg's overt anthropological interests, its intellectual ancestry is the same: Robert Vischer's empathy theory plays a prominent part in Wölfflin's account of the experience of architecture, and his attempt to map out the analogies between certain visual forms – lines, colours, mass – and psychological states is informed by Wilhelm Wundt. The influence of Wundt is also evident in Wölfflin's turn away from the individual artist, and his conclusion that single objects, from cathedrals to shoes, act as microcosms of the collective psychology of an entire age. Of special interest is also his contention that a collective psychology is best reflected in 'minor' practices such as ornament and the decorative arts, and not in the official high arts, where, due to the ossification of official cultural forms, "style becomes a lifeless schema maintained only by tradition."[54] Here again, as in the case of ornamentation, the logic of the supplement operates. The minor arts, more usually regarded as an adjunct to the fine arts, turn out to be a truer source of knowledge than the official objects of art historical enquiry. It is somewhat regrettable that Wölfflin, due to his role in the academic institutionalisation of art history, paid little further attention to the so-called minor arts, and certainly did not later accord them the importance indicated in this tantalising comment at the end of the *Prolegomena*.

The culmination, perhaps, of the attempt to marry the concern with formal aesthetic principles and the anthropological interest in collective psychology with art history is Willhelm Worringer's *Abstraction and Empathy*, the point at which art history and criticism also merges with art practice.[55] Worringer draws on similar sources to Wölfflin and Warburg. The concern with empathy is again central to

his account of the psychology of art, and Riegl's notion of the *Kunstwollen* is mobilised as a means of stressing the collective basis for the psychology of art. However there is also an important difference in that Worringer sees in art a sublimation of a variety of primitive anxieties and fantasies, principal among them being fear of nature as an irreducible other. Thus, while empathic projection was hitherto seen as a defining characteristic of primitive cognition, Worringer interprets it as an achievement attained once nature has, to some extent, been mastered and thus lost its alien character. Consequently the earliest aesthetic impulses are driven by an apotropaic urge: nature is to be warded off, kept at a distance and symbolically mastered through the reduction of visual phenomena to abstracted regular forms. "Thus the impulse to abstraction finds beauty in life-denying inorganic forms, in the crystalline or, in general, in whatever displays abstract regularity and necessity."[56] Worringer thereby overturns the understanding of the meaning of abstraction central to the tradition reviewed here, but in other ways he perpetuates certain conceptual motifs. While empathic projection is now no longer a primary constituent of aesthetic experience and production, he still refers to the primitive drive to imitation, but this now *precedes* anything that might be regarded as a meaningful artistic activity.[57] Consequently the cave paintings of Lascaux are not works of art, but merely the technically accomplished outcomes of a mimetic urge, a curious view though consistent with his general position, and one which is repeated later in his study of Gothic art.[58] Art proper only begins with the development of an ornamental sense, for "the *Kunstwollen* of a people finds its purest and most unclouded expression in the products of ornamentation. It offers, as it were, a paradigm, from which one can clearly read off the specificities of the absolute *Kunstwollen*."[59] And because abstraction precedes empathy, the origins of art lie in geometric ornamentation; as with Wölfflin, therefore, the key to understanding art lies in the peripheral activity of ornament.

Conclusion

Speculation about the origins of art continued well into the 1920s. However, the period leading up to the first decade of the twentieth century can be regarded as the high point of attempts to integrate anthropological thought with art history. There are numerous reasons why this was the case. During the period under discussion the identity and boundaries of art history remained fluid. Even though Warburg complained about the 'border police' of art history, it was in fact his own generation that established the borders of the discipline, his contemporary Heinrich Wölfflin playing no small part in this. Thus art history came to separate itself from anthropology, which itself, through becoming established in university departments in the same period, underwent a similar process. As a result there emerged the quite distinct field of the anthropology of art. In addition, although a disaffection with grand narratives is often seen as a more recent phenomenon, it is possible to detect in this gradual process of disengagement a recognition of the problematic nature of attempts at a totalising account of cultural development and history. Only in the last twenty or so years have the two fields begun to open up again to each other, but in a very different way. Most significantly, perhaps, the narratives of origin and evolution have disappeared, and this is symptomatic of a wider contemporary suspicion towards the question of origins. Indeed, it reflects a general shift away from narratives of developmental sequences to ones of spatial relations – from diachrony to synchrony. And yet while it is possible to refer to the ethnographic displacement of art history, the reverse is not the case. The concern with a generalised notion of alterity has led to a fragmentation of the field (paralleling a wider cultural fragmentation) at the expense of the possibility of any historical ordering. Might it therefore not be possible to engage in an art historical transformation of anthropology, one open to the historical and aesthetic dimensions of ethnography?

This last question highlights the possibilities of anthropology as an artistic practice, for ironically, while the interrogation of primitive

de-, dis-, ex-.

origins no longer occupies central place in the terrain of contemporary debate, either art historical or anthropological, it has remained a constant in twentieth century art practice. From the crystalline figures of Expressionist painters such as Erich Heckel, to the totemic sculptures of Max Ernst or David Smith, and from the primitive monuments of Robert Smithson and the effigy tumuli of Michael Heizer to the archaeological projects of Mark Dion and Jimmie Durham's coelacanth, what began as an investigation into aesthetic origins has mutated into an artistic investigation into distant historical beginnings. A most dramatic example of this is provided by the work of Susan Hiller, who turned to artistic practice out of dissatisfaction with the reflexive limitations of anthropology. Her work *An Entertainment* consists of video projections on a vast scale of more than thirty Punch and Judy shows. In what might be regarded as an ethnographic study of popular English culture, Mr Punch and the associated *dramatis personae*, normally seen as figures of traditional comic entertainment, become, when increased to such a vast size, monstrous ciphers of a range of primitive and violent fantasies of transgression and immortality. By magnifying Punch's violent oppression of his family the work reveals both the conditions of modern patriarchy and also its roots in English popular culture. In this tracing of primitive roots the Enlightenment is perhaps still with us.

Footnotes

1 See Hans Belting, *The End of the History of Art?* C. Wood, trans., Chicago, IL: University of Chicago Press, 1987; Victor Burgin, "The End of Art Theory," *The End of Art Theory*, London: Macmillan, 1986, pp. 140–204; Donald Preziosi, *Rethinking Art History*, New Haven, CT: Yale University Press, 1989. See, too, the special edition of *Art Journal*, Vol. 42 No. 4, 1982, devoted to the crisis of art history.

2 Perhaps the first symptom of this process was Michael Podro's *The Critical Historians of Art*, New Haven, CT: Yale University Press, 1982. This was followed by, for example, Michael Ann Holly, *Panofsky and the Foundations of Art History*, Ithaca, NY: Cornell University Press, 1984.

3 See, for example, Arthur Danto's *After the End of Art*, Princeton, NJ: Princeton University Press, 1997.

4 Foster, Hal, "The Artist as Ethnographer," *The Return of the Real*, Cambridge, MA: The MIT Press, 1996, pp. 171–203.

5 See, for example, Riegl, *Altorientalische Teppiche*, B. G.Teubner, 1892; *Spätrömische Kunstindustrie* [1901] Wissenschaftliche Buchgesellschaft, 1992; *Die Entstehung der Barockkunst in Rom* [1908] Mäander, 1987.

6 The anthology in question is *Visual Culture*, Chris Jenks, ed., London: Routledge, 1995.

7 Wilhelm von Humboldt (1767–1835) was, alongside his contemporary Goethe, one of the last great polymaths of German culture. A pioneer in the fields of mineralogy, meteorology and geology, he helped establish geography as an autonomous discipline. He was also central to the development of comparative linguistics. See Humboldt, *On Language* [1836], P. Heath, trans., Cambridge: Cambridge University Press, 1988.

8 Vico, Giambattista, *The New Science*, T. Bergin and M. Fisch, trans., Ithaca, NY: Cornell University Press, 1948; Theodor Adorno and Max Horkheimer, *Dialectic of Enlightenment*, J. Cumming, trans., London: Verso, 1979.

9 Habermas, Jürgen, *The Philosophical Discourse of Modernity*, F. Lawrence, trans., London: Polity, 1987, pp. 1–22. See, too Reinhart Koselleck, *Futures Past: On the Semantics of Historical Time*, Keith Tribe, trans., Cambridge, MA: The MIT Press, 1985.

10 In this respect it is worth noting that Heinrich Wölfflin, often regarded as the founding father of art history, submitted his doctoral dissertation on architecture to the Philosophy Faculty of the University of Munich and was Professor of History at Basel. Likewise in Germany, until 1886 there was not a single university professorship in anthropology, and between 1886 and 1906 only one. Rudolf Virchow, one of the dominant forces in anthropology of the period was professor of pathology. A similar situation prevailed in Britain.

de-, dis-, ex-.

11 Kant, Immanuel, *The Critique of Judgment*, J. Meredith, trans., Oxford: Oxford University Press, 1952, p. 65.

12 Kant, *Critique*, p. 68.

13 See Jacques Derrida, *The Truth in Painting*, G. Bennington and I. McLeod, trans., Chicago, IL: University of Chicago Press, 1987, pp. 37–82.

14 Kant, *Critique*, p. 68.

15 A useful summary of the question of ornament in this period is provided by Franz-Lothar Kroll, *Das Ornament in der Kunsttheorie des 19: Jahrhunderts*, Georg Olms Verlag, 1987.

16 Schiller, Friedrich, *Lectures on the Aesthetic Education of Man*, E. Wilkinson & L. Willoughby, trans., Oxford: Oxford University Press, 1967, pp. 191–193.

17 Hegel, Georg, *Vorlesungen über die Ästhetik*, Suhrkamp, 1986, Vol. II, p. 296 ff.

18 Carl Boetticher, *Die Tektonik der Hellenen*, Ernst & Korn, 1849–1852.

19 Zimmermann, Robert, *Allgemeine Aesthetik als Formwissenschaft*, Wilhelm Braumüller, 1865. For a brief account of the formalist aesthetics of the mid-nineteenth century see Harry Mallgrave and Eleftherios Ikonomou, "Introduction" in *Empathy, Form and Space: Problems in German Aesthetics 1873–93*, Mallgrave & Ikonomou, eds., Los Angeles, CA: Getty Centre for the History of Art and the Humanities, 1994, pp. 1–85.

20 For a brief synopsis of Semper's ideas see Michael Podro, *The Critical Historians of Art*, New Haven, CT: Yale University Press, 1982, pp. 44–55. A more thorough account is offered by Harry Mallgrave, *Gottfried Semper: Architect of the Nineteenth Century*, New Haven, CT: Yale University Press, 1996.

21 Semper, Gottfried, *Über die formelle Gesetzmässigkeit des Schmuckes und dessen Bedeutung als Kunstsymbol* [1856], Alexander Verlag, 1987.

22 Gombrich, Ernst, *The Sense of Order*, London: Phaidon, 1979, p. 51.

23 Cited in Gombrich, *Order*, p. 52.

24 See Georg Hegel, *Philosophy of Religion: Single Volume Edition*, R.F. Brown et al., trans., Los Angeles, CA: University of California Press, 1988, p. 229 ff.

25 Riegl, *Stilfragen*, 1893.

26 Riegl, *Stilfragen*, p. 22. The idea of a primal need for decoration became widely accepted. See, for example, Max Hoernes, *Urgeschichte der Bildenden Kunst in Europa*, Holzhausen, 1898, p. 17.

27 Riegl, Alois, *Volkskunst, Hausfleiß und Hausindustrie* [1894] Mäander, 1978, pp. 9–10.

28 Riegl, *Stilfragen*, pp. viii-ix.

29 Riegl, *Stilfragen*, p. 2.

30 Riegl, *Stilfragen*, p. 4.

31 Loos, Adolf, "Ornament and Crime" quoted in *The Architect: Reconstructing her Practice*, Francesca Hughes, ed., Cambridge, MA: The MIT Press, 1996, p. 125.

32 For a clear outline of the influence of Humboldt on anthropology see Matti Bunzl, "Franz Boas and the Humboldtian Tradition," in *Volksgeist as Method and Ethic*, George Stocking, ed., Wisconsin: University of Wisconsin Press, 1996, pp. 17–78.

33 Pagden, Anthony, *The Fall of Natural Man: The American Indian and the Origins of Comparative Ethnology*, Cambridge: Cambridge University Press, 1982.

34 It is important to maintain the distinction between *ethnography*, which, as the empirical description of specific cultures, arguably had its roots in the many encounters of explorers and travellers with alien cultures, and *ethnology*, which was based on the attempt to theorise the meaning of cultural differences. For a general history of the notion of 'primitive society' in anthropological thought see Adam Kuper, *The Invention of Primitive Society*, London: Routledge, 1988. See, too, George Stocking, *Victorian Anthropology* and Stocking, *After Tylor*, London: Athlone, 1998.

35 See Herbert Spencer, *Principles of Sociology*, London, 1876, Vol. I, p. 73 ff.

36 Tylor, Edward, *Primitive Culture*, London: John Murray, 1871.

37 See Benoit Massin, "From Virchow to Fischer: Physical Anthropology and 'Modern Race Theories' in Willhelmine Germany," in *Volksgeist as Method and Ethic*, pp. 79–154.

38 Bastian, Adolf, *Der Mensch in der Geschichte*, Otto Wiegand, 1860. 3 Vols., See esp. Vol. I, p. 154 ff: II, p 25 ff.

39 Wundt, Willhelm, *Völkerpsychologie*, Engelmann, 1905–1908.

40 For a general account of Wundt see Christine Schneider, *Willhelm Wundts Völkerpsychologie*, Bouvier, 1990.

41 Grosse, Ernst, *Die Anfänge der Kunst*, J. C. B. Mohr, 1894.

42 Schmarsow, "Kunstwissenschaft und Völkerpsychologie," in *Zeitschrift für Ästhetik und Allgemeine Kunstwissenschaft* 2, 1907, pp. 305–339 & 469–500.

43 Willhelm Wundt, *Völkerpsychologie*, Engelmann, 1908, III: "Die Kunst."

44 Wundt, *Völkerpsychologie*, pp. 73-75.

45 See Robert Vischer, "On the Optical Sense of Form" [1873] *Empathy, Form and Space*, pp. 89–123.

46 Vischer, "Optical," *Empathy*, p. 91.

47 On the intellectual ancestry and impact of Vischer's thought see Hermann Glockner, "Robert Vischer und die Krisis der Geisteswissenschaften," in *Friedrich Theodor Vischer und das 19. Jahrhundert*, Juncker & Dünnhaupt, 1931, pp. 168–269.

48 Schmarsow, "Kunstwissenschaft und Völkerpsychologie," p. 322.

49 Schmarsow, *Grundbegriffe der Kunstwissenschaft*, B. G. Teubner, 1905, pp. 343–344.

50 This idea was also central to Bastian. See *Der Mensch in der Geschichte*, II, p. 27 ff. For a brief overview see my "Archives of Memory: Walter Benjamin's

de-, dis-, ex-.

Arcades Project and Aby Warburg's *Mnemosyne Atlas,*" *The Optic of Walter Benjamin,* Alex Coles, ed., London: Black Dog Publishing, 1999, pp. 94–117.

51 See Warburg, *Images from the Region of the Pueblo Indians of North America,* M. Steinberg, trans., Ithaca, NY: Cornell University Press, 1995.

52 Schwarz, Frederick, "Cathedral and Shoes: Concepts of Style in Wölfflin and Adorno," *New German Critique,* Vol. 76, 1999, pp. 3–48.

53 Wölfflin, Heinrich, "Prolegomena to a Psychology of Architecture," *Empathy, Form and Space,* pp. 149–190.

54 Wölfflin, "Prolegomena," *Empathy,* p. 185.

55 Worringer, Willhelm, *Abstraktion und Einfühlung,* [1908], R. Piper & Co., 1919.

56 Worringer, *Abstraktion,* p. 4.

57 Worringer, *Abstraktion,* p. 14.

58 In *Questions of Form in Gothic Art* Worringer argues: "Primitive man was only active artistically when he was drawing or inscribing on a flat surface. Whenever he was working with three-dimensional forms in clay or some other material, this was the outpouring of a playful mimetic urge, that does not belong in the history of art but rather in the history of manual technical skill." Worringer, *Formprobleme der Gothik,* R. Piper, [1914] 1927, p. 18.

59 Worringer, *Abstraktion,* p. 66.

QUOTIDIENNE
LÉGEND
TOUAREG

UX

T-AMBROIS
PIEDS-NOIA
VOLTAI
LÉON B
LAS

28

7
(BOUT)

UT, NO-MAN'S-

INFLATION CU

E NATURE
LAS CASAS
WALOSTER B
S IMMÉMORIA
CANDIDE
L'AUTRE ET L'
ARONNE
RUE

80

29

1 CHÂTEA
2 PORTE
6 CHARLE
NOUVE

LE

...URS BUM

BAMB BUM

VICE-ROI D'OUIDAH

...S BOULETS
DE MONTREUIL

...LEXIS DE TOCQUEVILLE

DIEN-BIEN-PHU

NATION

LES MOTS ET LES CHOSES

BUZENVAL

INFLATION

CONTEMPLATIONS

MARAÎCHER

MALIN...

PO...

31 J2 33 34

31 32 22

VINCENNES - PONT DE NEUILLY

...INE - ABIDJAN

...GAULLE-ÉTOILE

...CALÉDONIE

LE WALDSTERBEN

OPTIMISME SANS FONDEMENT

LA SOCIÉTÉ CONTRE L'ÉTAT

RER A

Sites of Amnesia, Non-Sites of Memory: Identity and Other in the Work of Four Uruguayan Artists

Arnd Schneider

In a rather sinister sense, Southern Cone countries Uruguay and Argentina, had become non-places in the nineteenth century, turned into 'Utopias' for European settlers and immigrants, while the memory of another, indigenous past had been erased. Both Uruguay, which destroyed its indigenous people in the 1830s, and Argentina which fought the indigenous population in the genocidal 'Desert Campaign' of the 1870s, forcing the survivors into marginal reservations, constructed their identity as 'white' immigrant nations around the founding myth of the absence of native Americans on their territories.

On both sides of the River Plate official ideologies largely obliterated the memory of an indigenous past, and civilian and military governments for most of the nineteenth and twentieth centuries were keen to establish a progressive, European character for their respective countries. Thus in Uruguay the mainly rural Creole population, a product of colonial Spanish and Portuguese settlers and indigenous people, was denied any historical linkage to its indigenous past.

de-, dis-, ex-.

Hence, for the Uruguayan artists I shall discuss below, sites are not just geographical locales, but imbued with history and memory, in which the past and present social and cultural practices of its inhabitants are inscribed. From the perspective of destroyed indigenous cultures, sites are then paradoxically charged with the very absence of their former meaning.

The work of the first two artists under review here, Rimer Cardillo (b. 1944 in Uruguay), who has lived in New York since 1979, and Nelbia Romero (b. 1938 in Uruguay, lives in Montevideo), is site-specific in the sense that it refers to Uruguayan territory and history. However, in an age of increasing globalisation, the idiosyncrasy of the local can also be realised in an eclectic mix of heterogeneous 'roots,' as we shall see with the work of Gustavo Fernández (b. 1957 in Uruguay, lives near Montevideo), or it can be evoked in a reflective way at a distance, as we shall see with the example of Carlos Capelán (b. 1948 in Uruguay), who has lived in Lund, Sweden, since 1974 and more recently moved to Spain.[1]

All four artists make reference to anthropology and archaeology, albeit in very different ways. For Cardillo and Romero (who also worked on Cardillo's projects in Montevideo), artistic practice involves the consultation of archaelogical and anthropological literature, the excavation of actual sites, and co-operation with anthropologists and archaeologists. For Gustavo Fernández the proximity to anthropology assumes a rather more personal nature, as a form of spiritual quest, and a 'shamanic' approach to knowledge. Carlos Capelán reflects and comments more generally on the discipline of anthropology, as part of the Western gaze directed at the other, which since the Conquest has become an indissoluble part of Latin America.

The artworks of Cardillo and Romero set out to challenge the received notion of Uruguay as a 'white' immigrant nation. Since the late 1970s, these artists have aimed at reworking Uruguayan history by explicitly focusing on its now extinct indigenous cultures.

The now extinct Charrúa people of Uruguay have been the special preoccupation of Rimer Cardillo, who has incorporated archaeological findings on their culture into several of his works. The Charrúa spoke their own distinct language, but in terms of their livelihood were similar to Guaraní-speaking hunters and gatherers in the Chaco and the Pampas.[2] The extermination of the Charrúa is directly linked to the military campaigns which resulted in Uruguay's independence in 1830. The general who had been victorious in the campaigns against the Brazilians, Fructuoso Rivera (who became the first president of Uruguay on 24 October 1830), led Indian chiefs into an ambush at Salsipuedes on 11 April 1831, where (according to contemporary accounts) forty of them were killed and three hundred taken prisoner. Further raids against Indians by Rivera's army, and his colonel, Bernabé Rivera, resulted in more killings and the taking of captives followed. The 120 or so documented survivors, mainly women and children, were kept in the Montevideo garrison and then were assigned as servants to individuals. Any memory of their language and culture was erased, some of the children were even given Spanish names. The sad story of some of the survivors is an all too familiar one in the history of European profit from the display of vanquished indigenous peoples.[3]

Rimer Cardillo, *Ancestor With Fossils*, 1991.
All images courtesy of the artists.

One of the survivors, Ramón Mataojo, was 'given' to the naval lieutenant Barral, who brought him to France, where he was not allowed to disembark, and subsequently died on the high seas. Four others – Vaimaca Perú, Senaqué, Tacuabé and Guayanusa – were submitted to François de Curel, who had presided over schools in both countries of the River Plate (i.e. Argentina and Uruguay), so that he too could make money in France from exhibiting them as remnants of an exotic and extinguished humanity; there, they died miserably.

Rimer Cardillo's installation *Charrúa y Montes Criollos* (*Charrúa and Creole Mountains*), mounted in Montevideo in 1991, was intended as a direct critique of Uruguay's official history, and lack of recognition of its indigenous past. *Charrúa y Montes Criollos* was shown as a large scale, multi-media project at the Municipal Exhibition Centre and then at the Museo Fernando García (a disused railway station) where it has remained on permanent display since. The show involved the co-operation of other artists, anthropologists, artisans, lighting designers, musicians, and museum personnel. The artworks themselves simultaneously evoke the large anthills (called *cupi*) of Guaraní, and ancient burial sites from the Charrúa, called 'little hills' (*cerritos*). Both are typical of the rural Uruguayan landscape known as 'creole mountains' (*montes criollos*) – the former habitat of the Charrúa and other indigenous peoples. Yet the terms *cerritos* and *montes criollos* obliterated any explicit indigenous references. Cardillo studied the available literature on the Charrúa and also visited several excavation sites. However, his approach does not merely reproduce archaeological findings, but creatively transforms and incorporates them into his own artworks, thus bestowing new meaning on them. In other words, Cardillo takes knowledge out of the specialised confines of academic archaeology (a rather small field in Uruguay) and makes it available, aesthetically and materially reworked, in the public domain to provoke a discussion of history, 'origins' and identity.

Cardillo produces the artworks, using techniques which display an intuitive empathy with the archaeological artefacts. What he terms the "logic of indigenous construction" implies his use of primarily those (non-industrial) techniques which, potentially, could also have been available to the Charrúa, using soil, charcoal, sand, ash, and ceramic casts of fossilised animals in the construction of an artificial installation-mound entitled *Ancestor with Fossils*. Cardillo, of course, transcends the immediate material vocabulary of indigenous people (using wooden artifacts, plywood scored with electrical routers, photo silkscreens), yet keeps the reference to ancient techniques and materials, as evident in many of the pieces shown recently in an exhibition at the Bronx Museum of the Arts in New York.[4] This kind of retrospective empathy with indigenous materials and techniques suggests that the now extinct Charrúa could have been (and in fact *are)* co-authors of Cardillo's artworks along with the artist and his collaborators who create them in the present.

Cardillo's appropriations, along with those of other contemporary artists (and not only Latin American ones), call into question accustomed anthropological methodologies of representing other cultures.[5] These artists, especially those who take a 'learning attitude' towards the other, contribute both to the understanding of the material and, in fact, artistic practices of indigenous cultures, and to the realm of interpretive and hermeneutic analysis and description.

Rimer Cardillo, *Ancestor With Fossils*, detail, 1991.

Nelbia Romero, who lives in Montevideo, is another artist whose work defies the received assumptions of Uruguayan identity and history. In her installation *Mas allá de las palabras (Beyond Words)* at the Palacio Municipal in Montevideo in 1992, she draws attention to the fact that the denial of indigenous people in Uruguay's national identity has been a direct result of how history has been taught by the state's institutions. In one exhibition room she evokes a traditional schoolroom (for her a site of amnesia rather than learning), surrounded by thick brick walls, and on the walls she writes a few words in Guaraní, a language which (like Charrúa) is now extinct in Uruguay (except amongst Paraguayan immigrants). The second exhibition room signals a substantial transformation, where the school bench is liberated from the brick walls and rests freely on a surface of grass. The walls of the exhibition room are covered with large hand-written words in watercolour, in Spanish and Guaraní, interspersed with photographs of rural Uruguay and its inhabitants of Creole, and by implication, indigenous descent. The site of amnesia has become a site of retrieved and recreated 'knowledge' of the indigenous roots of the present-day Uruguayans. Like Cardillo, Romero's projects are an interdisciplinary endeavour, involving the collaboration of anthropologists, archaeologists and historians in her work and exhibitions at the National Museum of Anthropology in Montevideo. In another installation entitled *signos-huellas (Signs-Traces)* Romero has used symbols from prehistoric Uruguayan rock art. Her appropriations of rock art underlie an indirect approach, largely mediated by published material which reviews early research on the topic and reports on investigations in the 1940s and 1950s. However, her 'hand-writing' of 'signs,' showing both the drawing hand of the artist and the symbols on her hands and on the paper clearly reflects upon the appropriating and the interpreting process of such artistic practice.

For work on topics related to the Charrúa, Romero consulted published research by archaeologists, and for the history of Guaraní

descendants in her home town of Durazno, she sought the assistance of the historian and Director of Museums of that town, Oscar Padrón Favre.

It should be noted that these Uruguayan projects of Cardillo and Romero were exhibited for a public *in Uruguay* and not in a museum or gallery of the international art circuit, whereas Cardillo, for example, usually exhibits in the United States. They are also particularly noteworthy because they initiate a new discourse about Uruguay's own others, both historic – such as now extinct indigenous cultures – and contemporary – such as manifestations of Afro-Uruguayan culture, like *candombe* music. Under the military regime of 1973–1984/85 it was difficult for artists in Uruguay to make reference to these topics. However, Romero continued to work and managed to have exhibitions during this period, and her art clearly had a dissident status. The brutal practices of the last military dictatorship have been the topic of works by several Uruguayan artists in exile, for example in Luis Camnitzer's series on torture and Mario Sagradini's *Made in Uruguay* series.

Such recent artistic re-interpretations of Uruguayan history have to be understood in the context of a crisis of national identity in contemporary Uruguay. After economic decline for several decades and the demise of the last military dictatorship, few Uruguayans still believe that their country is the Switzerland of Latin America (*la Suiza de América*). Other catch-phrases associated with a mythical Uruguay 'There is nothing like Uruguay' (*Como el Uruguay no hay*), 'The happy Uruguay' (*el Uruguay feliz*), 'the cultural champion of America' (*el campeón cultural de América*), 'the country of the fat cows' (*el país de las vacas gordas*), and 'the Athens of the River Plate' (*la Atenas del Plata*) would also not seem to have much conviction in the present, and actually sound like bitter ironies in the face of today's economic difficulties. A survey, carried out in 1993, found that a large proportion of *Montevideanos* associates the first decades of this century with a golden, mythical past, when Uruguay offered a free and

de-, dis-, ex-.

secular education, a generous welfare system, introduced female suffrage, and imported European culture. Yet, despite the irrevocable fracture that has occurred with that model, Uruguay is still thought of in these terms by the majority. Re-configuring Uruguay's identity and accounting for its increasing heterogeneity, would have to include its indigenous and African pasts and presents, and thus locate itself in the wider Latin American context.

Nelbia Romero, *Beyond Words*, 1992.

However, under the current phase of democratic regimes, both Uruguay and Argentina are undoubtedly undergoing a re-interpretation of their national identities, in which more pluralist conceptions of the nation are being put forward (and are sometimes actively encouraged by cultural institutions, such as museums and galleries). These new approaches entail re-evaluating the European immigrant past from perspectives other than the older homogenising nationalisms and paradigms of 'a melting pot of races' (*crisol de razas*).[6] For instance, Mandressi critically applies the Cuban anthropologist's Fernando Ortiz's concept of 'transculturation' (rather than acculturation) to Uruguay's experience with European mass immigration, and also criticises the 'endogamic' present, characterised by emigration (first for political, and now for economic reasons), population decline, cultural isolation and introspection. Other authors have investigated different immigrant groups (for example, Jews) and given new emphasis to the past and present of indigenous populations, as well as to Uruguayans of African descent.

New, more heterogeneous interpretations of history are now discussed by contemporary Uruguayans, and a variety of identity affiliations are experimented with. On the level of the individual artists, this includes those who put forward their own idiosyncratic mythologies. For example, Gustavo Fernández is an artist of a younger generation than Cardillo and Romero who seeks inspiration from non-western cultures. Mixing elements of the Afro-Uruguayan *candombe*, shamanistic practices, and alchemy, he has developed a

Carlos Capelan, *Maps and Landscapes*, 1992.

kind of private spirituality which inspires his works. Fernández lives in a rural area about 10 miles from Montevideo. His 1994 installation *Cave Canem: Cuidado con el perro* (*Beware of the Dog* in Latin and in Spanish) assembled a number of objects made predominantly from natural materials, such as wood, clay, mud, hay, bones, and feathers.

Fernández's approach, which is inspired by a deep spirituality *sui generis*, might best be termed as syncretic, which locates him within a long genealogy of Latin American admixtures of others. He takes aspects from different cultures, mixes them, and sets them in relation to each other. Yet the underlying motifs are clear: he wants to get to what he conceives as the spiritual significance of the symbols, to a common spiritual language which he sees as underlying all these manifestations of non-western cultures, a common cultural bond which unites them, and in that sense makes them, albeit within their particular expressions, universal.

Whilst Fernández is linked to the concerns of the *Escuela del Sur* of Joaquín Torres-García, his expressions are also reflections of idiosyncratic religious practices, which bring him nearer to the more recent 'shaman-artists,' like José Bedia, and even Joseph Beuys.[7]

In this context it is worthwhile to note just how much the whole framework of possible identity affiliations is now shifting in present-day Uruguay and how people experiment with their 'roots.' This process can be exemplified by the appeal of the Association of Descendants of the Charrúa Nation. The association was founded in Montevideo in 1989 and gathers together people who claim descent from Charrúa Indians. Members are in fact aiming to establish for themselves an identity as Charrúa descendants. One way of giving credence to their identity claims is to seek affirmation from anthropologists at the National Anthropology Museum, in order to record their life histories and carry out a survey of physical characteristics which could demonstrate their descent from indigenous people. The group is involved in a process of collective identity construction, and has expected difficulties in establishing 'genetic'

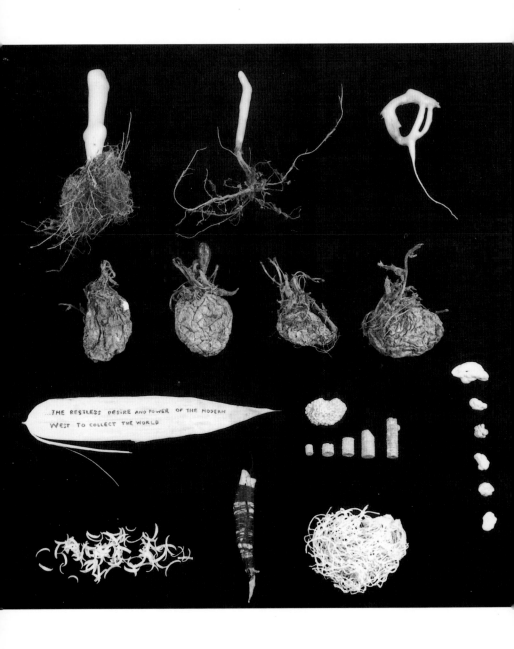

The text within the image reads: "...THE RESTLESS DESIRE AND POWER OF THE MODERN WEST TO COLLECT THE WORLD"

Carlos Capelan, *Maps and Landscapes*, detail.

descent as opposed to culturally acquired characteristics. Only a few decades ago, such an invention of 'indigenous' roots would have been unthinkable in Uruguay.

The work by Carlos Capelán moves beyond a strictly defined localism to a more substantive critique of anthropological appropriations and representations in the global age. His exhibition *Maps and Landscapes*, one version of which was also shown at the Fifth Havana Biennial 1994, 'anthropologises' the living room and the library in the West and in Latin America as enclosed, almost sacred spaces for the interrelated western practices of knowledge acquisition, transmission, and remembrance. The living room and the library become memory sites where the transfixed gaze towards the other is inscribed through the mnemonic device of the books. In the installation, Capelán uses red ochre and black ink to paint self-portraits and bodies with multiple eyes, indicating the West's self-referential gaze at the other. In the installation for the Havana Biennial 1994 *canto a mi mismo (Song to Myself)*, the 'I' itself becomes the site, the individual who locates the gaze turns into the autonomous subject from which knowledge radiates and is fabricated in the West. Books and earth materials are stacked around the room, and quotations from anthropologists, philosophers and fellow artists are written on the walls to complement the global panopticon. A closer reading, however, reveals that these elements are as much part of contemporary Latin American societies (as a result of the Western expansion) as they are of Western tradition. In interviews Capelán referred specifically to the cult of books and the library at the River Plate. By using the living room/study as a metaphor for globalisation, which still remains anchored locally, Capelán succeeds in providing a critique of appropriations in both the centre and the periphery.

The ethnographic sites the artists reviewed here appropriate (Cardillo's *montes criollos*, Romero's prehistoric sites of rock art, as well as the more metaphorical sites of Fernandez's 'earth mother,' and Capelán's 'library'), are ambigiuous in that they have served

historically both the selective transmission and the obliteration of cultural memory in Uruguay. In reworking these sites the artists thus present a twofold challenge to collective amnesia which transcends the local. Their work questions the amnesia of their own societies with regard to indigenous populations, but it also calls into doubt the amnesia of Western societies with respect to the countries of the Southern Cone. The latter is an amnesia of arrogance, or economic power, we might say, which has largely consigned to oblivion the South American countries which only a few generations ago for Europeans represented progress, modernity, and the future. And it was precisely because the native population had been eradicated or assimilated that idealised immigrant and settler 'utopias' could henceforth exist.

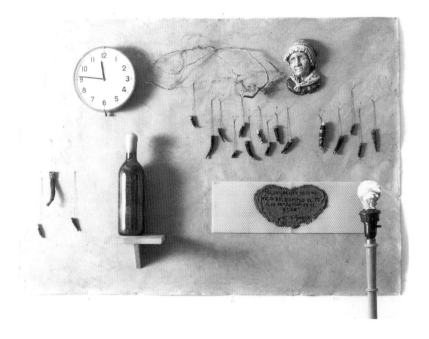

Carlos Capelan, *Maps and Landscapes*, detail.

Footnotes

1 For a positioning of Cardillo, Romero, and Capelán in the history of art in Uruguay, see Alicia Haber, "Uruguay," in *Latin American Art in the Twentieth Century*, Edward. J. Sullivan, ed., London: Phaidon, 1996, p. 280.

2 Serrano, Antonio, "The Charrua," *Handbook of South American Indians*, Julian H. Steward, ed., Washington, DC: Smithsonian Institution, 1946–1950.

3 There is now a vast literature on the subject, but see, for example, *Exhibiting Cultures*, Ivan Karp and Steven Levine, eds., Washington, DC: Smithsonian Institution, 1991.

4 Cardillo, Rimer, *Araucaria*, New York, NY: Bronx Museum of the Arts, 1998. (catalogue essays by Marysol Nieves, Lucy Lippard, and Patricia Phillips).

5 See Arnd Schneider, "The Art Diviners," *Anthropology Today*, 9 (2), 1993, pp. 3–9, and "Uneasy Relationships: Contemporary Artists and Anthropology," *Journal of Material Culture* 1 (2), 1996, pp. 183–210. One example is the work of the Native American artist, writer and activist Jimmie Durham. See his *A Certain Lack of Coherence: Writings on Art and Cultural Politics*, London: Kala Press, 1993.

6 See Arnd Schneider, "The Two Faces of Modernity: Concepts of the Melting Pot in Argentina," *Critique of Anthropology*, 16 (2), 1996, pp. 173–198.

7 See Caroline Tisdall, *Joseph Beuys*, London: Thames and Hudson, 1979.

Research for this paper was carried out in the summer of 1994 as Invited Visiting Scholar at the Archer Huntington Art Gallery and the Institute of Latin American Studies, University of Texas at Austin, as well as in New York (summer 1994, spring 1996), and in December 1995 in Montevideo. I met and interviewed Rimer Cardillo in New York in April 1994 and in April 1996, and have since corresponded with him. Gustavo Fernández and Nelbia Romero I met and interviewed in Montevideo in December 1995, and I have corresponded with Carlos Capelán.

I am grateful to the University of East London and the British Academy 44th Congress of Americanists Fund for having supported this research. In Austin, I am grateful to Mari Carmen Ramírez, and in Montevideo to Alicia Haber for having provided me with invaluable information on artists and documentary materials. I also wish to thank artists, galleries, and museums in New York, Montevideo and Lund for their help and time.

I am also grateful to John Cowpertwait, Roselyn Poignant and Chris Wright for comments on an earlier version of this paper.

IROQUOIS

...N CULTURELLE
...US (Victor Hugo)

...HERS NOA—NOA
...INOWSKI

PORTE DE MO...

~~COMMENT~~

ROBES...

34 35

37 3...

An Ethnologist in Disneyland

Marc Augé

For some days I had been asking myself if I had really been so wise to have accepted, in a moment of euphoria, this assignment which had been suggested to me: to visit Disneyland as an Ethnologist of modernity. Not exactly a good idea, I reflected: Disneyland was, after all, nothing more than a fairground attraction in the middle of nowhere. Moreover, taking my trip on a Wednesday (this was the only day I was free) I would have to deal with France's entire population of schoolchildren – the mere idea of their babbling proximity was enough to give me cold sweats. But it was too late to pull out and so with resignation I began to imagine the long hours I would spend, alone in the crowd trembling at the sight of the giant loop or scratching Mickey Mouse between the ears. I was thus delighted when my friend Catherine, a photographer and filmmaker to whom I had confided my doubts, suggested that she accompany me on my expedition. Her company and moral support would be precious to me. Besides, she wanted to take some random footage as I went along. This new prospect, of playing Monsieur Hulot in Disneyland, could perhaps transform an ordeal into playtime. I nevertheless remained anxious: it is well known that even the greatest of actors gets stage-fright, and I began to ask myself if we could turn up with our equipment without arousing the suspicion of the security guards. They would know the inherent contempt that French intellectuals tend to hold for any form of entertainment imported from America. Could they not deny us the right to film, knowing full well how subversive such documentary footage may turn out to be?

If you arrive at Disneyland by car (a friend had agreed to drop us off and pick us up in the evening) it is the landscape that provokes the first emotion. From afar, as if suddenly looming from the horizon and yet already close (not unlike one's first visual encounter with Mont Saint Michel or Chartres Cathedral) Sleeping Beauty's castle seems cut out of the sky, with its towers and cupolas, uncannily similar to all the photos of Disneyland seen in the newspapers or on television.

This is undoubtedly one's first enjoyment of Disneyland: the spectacle on offer exactly matched our expectations of it. No surprise whatsoever: just like the Museum of Modern Art in New York, where one cannot get over just how much original artworks look like their reproductions. There – I was later to reflect – lay the key to an immediately striking enigma: why were so many American families strolling up and down the park when they had, quite obviously, already visited its American counterpart? Well, precisely because these families could recognise here that which they already knew. They could abandon themselves to the pleasures of verification, the joy of recognition, not unlike those overly bold tourists who, lost at the other end of an exotic world, soon tire of the local colour and only seek to relocate and refamiliarise themselves in the sparkling anonymity of the closest supermarket: all supermarkets are alike.

The subtle pleasure caused by the site's conformity to our expectations was followed by a deep sense of relief. First of all, our cameras went unnoticed. We soon realised that, quite to the contrary, their absence would have made us look suspicious. One does not enter Disneyland armed without at least one camera. All children over the age of six possess their own. As for video cameras, they mostly tend to belong to the head of a family whose attention is divided between some intimate scene (his youngest one is being kissed by Snow White) and a more ambitious use of the camera (a panning shot of the paddle-steamer, *Mark Twain,* berthing along the banks of Frontier Land). I would not have been surprised to find out that Catherine was slightly upset by the fact that her equipment did not arouse anyone's curiosity. So as to prove to herself that she was not just like everybody else, filming indiscriminately, she set out to film in a truly professional manner those who were themselves filming. I thus proceeded to mingle with the crowd, to facilitate her filming and to remind her that I was the hero of this film. But even this act failed to distinguish her from the others. The profusion of cameras was so great that finding an angle which excluded all other cameras from the field of vision proved

de-, dis-, ex-.

very difficult. Observing this spectacle from the top of the Swiss Family Robinson's tree-house (a kind of exotic mezzanined four bedroom flat), I realised that whoever was filming or taking pictures was inevitably also being filmed or photographed. One goes to Disneyland to be able to say that one has been and to be able to provide proof. It is a visit paid to the future anterior, which only takes on its full meaning later when one shows family and friends the photos the youngest son took of his father filming him, followed in turn by the father's film of the son, as if to verify the whole process.

A second source of relief: the children were not so numerous as I had feared. Inevitably, around *Main Street*, one couldn't but notice the constant presence of a few children demanding an autograph from Mickey or his wife. But overall, there were far more adults than

Marc Augé

children. Sometimes one got the impression that entire families had mobilised themselves in order to accompany their little one, not so much to serve the child as a king, as for the child to serve them as their pretext. Nonetheless, such need for an excuse seemed to have been waived by the majority of visitors, as if they had instinctively known or learnt that the park is primarily intended for grown-ups.

This is first of all a matter of scale. Everything is full-scale but for the worlds to be discovered (*Frontier Land, Adventure Land, Fantasy Land, Discovery Land*) which are miniaturised. The city, the river and the railway are all reduced in size. But the horses are real, as are the cars and the houses too; the mannequins are human-size. A very particular enjoyment is to be derived from this contrast in size, between the realism of the component parts and the reduced

de-, dis-, ex-.

format of the landscape, an experience out of the youngest visitors' reach, given the size of the site itself: already huge in their eyes, the park soon exceeds their capacity to walk (I witnessed some children who just could not take another step). As for the grown-ups, they were able to appreciate the strict contiguity of all these small worlds, juxtaposed like stage sets in a film studio of the Grande Epoque. And the music reinforces this, in the way it paraphrases the landscape, as if present to insistently remind them where they are: music from a Western, 'oriental' music (Mustapha), refrains from Snow White or Mary Poppins, "Around the World in Eighty Days," guide them from one end of the park to the other, momentarily overlapping in the border zones.

Everyone here is performing and one understands the relevance of filming or being filmed. Indeed, the fun for grown-ups consists in trying out each set, mixing in with the extras (as the Sheriff in a Western or some fairy tale character) and in identifying those

famous show-tunes they don't quite recognise. They never get to see backstage – or the stage machinery – the importance of which one can sense through the sheer scale of the operation – but they can spot the discreet entry points which only admit members of staff. I was particularly touched by the kindness of a Snow White and of a Mary Poppins who, having finished their shifts (most probably feeling thirsty, tired, needing the bathroom and a shower), took their time in leaving, patiently answering the children's requests, and posing over and over again for video-cameras, before disappearing in a flash behind the scenery.

Yet on the other side of the scenery there is more scenery: mostly underground passages, to be explored by those who have both the energy to walk into these seemingly innocent looking houses and the patience to queue before descending into Hell. The reward awaits you at the end: loaded onto some small trucks, packed like sardines, the grown-ups reconnect with some of their childhood fears (those very ones already inflicted by Walt Disney, with his cackling witches and thunderstorms set in nightmarish forests). The haunted house, the buccaneer's hideout, the dragon's lair, all these sites that one only reaches by descending to the bowels of the earth are inhabited by an army of ghosts, uncannily singing, howling and sniggering skeletons and mannequins – and possibly most unsettling of all, the luminous grotto inside which giant round-eyed dolls sing nursery rhymes while dancing the can-can.

Constant perambulation and incessant music: after a while the grown-ups too are beginning to grow weary. And yet, as with those prix-fixe menus in which the first course and the wine are unlimited, nothing ought to be missed: having bought with the all-inclusive ticket the right to experience it all, one might as well get one's money's worth.[1] Around six or seven in the evening, people are looking jaded (not to mention the state of the children: in their prams, asleep for some time, or wild-eyed, they are being tugged along by their still feverish-looking parents). There was nothing left for Catherine to film

de-, dis-, ex-.

but this sea of faces, serious and tense. But let's not fool ourselves: these people were only taking their own enjoyment too seriously. I found myself contemplating how a fortuitous study in comparative ethnology might be conducted in such a space of cohabitation. For a while my eyes followed a group of young Arab women who, heads covered and wearing long skirts, were running from one attraction to another with charming enthusiasm, and then some Japanese executives in three-piece suits who simply could not run, for they were too busy filming and photographing everything as if on an industrial espionage mission. I lingered by a group of African musicians and dancers (somewhere in the middle of *Adventure Land*, between the Oriental bazaar and the pirate's hideout): with great natural talent, their chief, a tall and imposing man, was inviting a few female onlookers –

Marc Augé

British, Italian, Spanish – to join him, while their husbands and friends were filming them snuggling up in the man's arms, screaming in fear or in delight. French male chauvinism at its best.

Suddenly, everything became clear: what contributed to make this spectacle so entirely seductive was unveiled, namely, the realism, or rather, the surrealism this entirely fictional site generated. We live in a time in which history is staged, made into a spectacle, and derealises reality – be it the Gulf War, the Chateaux of the Loire, or Niagara Falls. This process of distanciation, this making over of reality into a spectacle, has never been made so palpable than in the tourist advertisements and 'tour-packages' they have on offer: this sequence of snapshots will never be more real than when, upon our return, our resigned family and friends will have to sit through our slide-show and endure our elaborate commentary. In Disneyland, the spectacle is itself made into a spectacle: the decor reproduces what was already a decor and a fiction – Pinocchio's house, the Star Wars spaceship. Not only

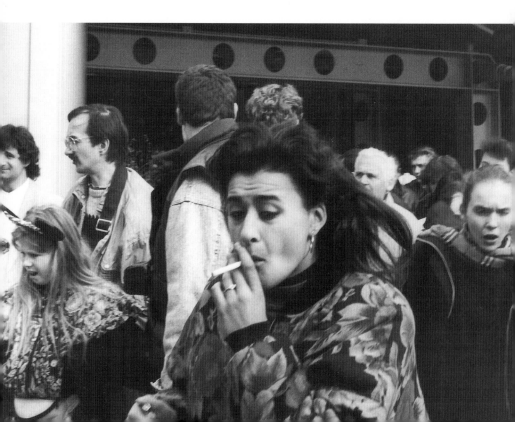

do we enter the screen, inverting the process at play in *The Purple Rose of Cairo,* but behind the screen we find only another screen. Thus a trip to Disneyland is a kind of meta-tourism, the quintessence of tourism: what we come to see doesn't exist. So that what is experienced here is pure freedom, the site devoid of any purpose or reason, where nothing is at stake. We find here neither America nor our childhood but the absolute gratuity of an optical illusion, where the one standing next to us – and whom we will never see again – can project any image they choose. Disneyland is the world of today in which you find the best and the worst: the experience of emptiness and freedom.

A final remark: on our way home from Disneyland, we stopped at the Newport Hotel which quite clearly was struggling to look like a real hotel. But we were no longer to be fooled: in spite of the waitress' determination to be unpleasant, taking half-an-hour to serve our beer as if to accentuate the fact that we had left behind the world of make-believe where porters, sheriffs and hostesses cannot stop wishing you 'a nice day,' we were not taken in. Outside, on an artificial lake, some phoney boats were pretending to sail. We drank our beer – I must admit it was a real beer: the ones served in Disneyland were false beers, alcohol-free – and we poked our tongues at the waitress who pretended to be offended. She was very convincing.

Translated by Alexia Defert
All images by Catherine de Clippel.

Footnotes

 1 This does not stop each fake house to function as a real shop, as Umberto Eco has remarked, following Louis Marin, in his essay on California's Disneyland, see: *Travels in Hyper Reality,* London: Picador, 1986.

This is a chapter from *L'Impossible Voyage,* Paris: Editions Payot & Rivages, 1997.

List of Contributors

Lothar Baumgarten is an artist. Since the late 1960s he has been producing ephemeral sculptures, photographs, slide projection pieces, film works, books and prints, and architecture related site-specific projects. He is Professor of Fine Art at the Akademie in Berlin.

James Meyer is Assistant Professor of Art History at Emory University. He is the editor of *Minimalism* (Phaidon) and the author of the forthcoming *Minimalism: Art and Polemics in the Sixties* (Yale University Press).

Anne Rorimer is an art historian and an independent curator. She recently co-curated *Reconsidering the Object of Art: 1965–75* at MOCA, Los Angeles. Her book on art of the 1960s and 1970s is forthcoming from Thames & Hudson.

James Clifford is Professor in the History of Consciousness Program at the University of California, Santa Cruz. He is the author of *The Predicament of Culture* and *Routes* (both Harvard University Press).

Miwon Kwon is Assistant Professor of Art History at the University of California, Los Angeles. She is a founding editor and co-publisher of *Documents*.

Susanne Kuchler is a lecturer in the Department of Anthropology at the University of London.

Renée Green is an artist, filmmaker and writer. She is a Professor at the Academy of Fine Arts in Vienna and faculty member of the Whitney Independent Study Program in New York.

Matthew Rampley is a Principal Lecturer in Art Theory at the Surrey Institute of Art & Design. He is the author of *Nietzsche: Aesthetics and Modernity* (Cambridge University Press).

Arnd Schneider is Senior Lecturer in Anthropology at the University of East London and Senior Research Fellow at the University of Hamburg. He is the co-editor of *Crossing Borders: Contemporary Artists and Anthropologists* (Thames & Hudson).

Marc Augé is Director of Studies at the Ecole des hautes études en sciences sociales in Paris. His books include, *Non-Places: An Anthropology of Supermodernity* (Verso).

Alex Coles is founding editor of *de-, dis-, ex-.,* co-editor of Mark Dion: Archaeology and a regular contributor to Parachute and art/text. He is Senior Lecturer of Critical Studies in the Department of Fine Art at Surrey Institute of Art & Design.

de-, dis-, ex-.

Colophon

© 2000 Black Dog Publishing Limited.

Black Dog Publishing Limited PO Box 3082 London NW1 UK
T 44 (0)20 7613 1922 F 44 (0)20 7613 1944 E info@bdp.demon.co.uk

All opinions expressed in material contained within this publication are those of the authors and not necessarily those of the publisher.

Produced by Duncan McCorquodale.
Designed by Christian Küsters.
Assisted by Owen Peyton Jones.

Printed in the European Union.

ISBN 1 901033 12 0

British Library cataloguing-in-publication data. A catalogue record for this book is available from The British Library.

TOTEM

~~OUIDAH~~

SAINT-DENIS

RG FORSTER

RACISME

TORTURE

BLIQUE

PANTAGRUEL

OBERKAMPF

MIC MAC

CIN. LEDO

26

SAINT

27

DÉ

MOTO

PIE

RITS

U-DR

LLANA

RUE

22

BOBIGNY
PLACE D'ITALIE

26

2
DJ

T DE LEVALLOIS OUTRE-MER

ACE D'ITALIE DJIBOU

LE FANTÔME AFRIQUE

AS - CHÂTELET - TOMBOUCTOU

PORTE DE

BALARD

ET L'AI

DOGE
BEN

Soft Cover, 200 pp,
32 b &w reproductions
15 x 21cm / 6 x 8.5 in,
1 901033 05 8
UK £11.95 / US $15.95

de-, dis-, ex-. Volume 1
EX-CAVATING MODERNISM

Edited by Alex Coles

Contributors include: Jon Thompson, Juliet Steyn, Peter Halley, Fred Orton and Nikos Papastergiadis.

Soft Cover, 208 pp,
25 b & w reproductions
15 x 21cm / 6 x 8.5 in,
1 901033 75 9
UK £11.95 / US $15.95

de-, dis-, ex-. Volume 2
THE ANXIETY OF INTERDISCIPLINARITY

Edited by Alex Coles and Alexia Defert

Contributors include: Julia Kristeva, Rosalind Krauss, Louis Martin, Beatriz Colomina, Howard Caygill and Hal Foster.

Soft Cover, 200 pp,
32 b &w reproductions
15 x 21cm / 6 x 8.5 in,
1 901033 41 4
UK £13.95 / US $19.95

The Optic of Walter Benjamin
Edited by Alex Coles

Volume 3
de-, dis-, ex-.

de-, dis-, ex-. Volume 3
THE OPTIC OF WALTER BENJAMIN

Edited by Alex Coles

Contributors include: Benjamin Buchloh, Mark Dion,
Donald Preziosi, Jane Rendell and Detlef Mertins.

For a current catalogue of
Black Dog Publishing Limited
titles please contact:

Black Dog Publishing Limited PO Box 3082 London NW1 UK
T: +44 (0) 20 7613 1922 F: +44 (0) 20 7613 1944
E: info@bdp.demon.co.uk

Architecture Art Design Fashion
History Photography Theory and Things

Radical PHILOSOPHY

99 Jan/Feb 2000 £4.50/$8.00

David Roberts Globalizing the University
Peter Hallward Philosophies of Singularity
Matt Connell Adorno's Proustian Sublimations
Steve Giles Cracking the Cultural Code
Tonya Blowers on *The Feminist Memoir Project*
Ben Watson on Roger Scruton's *Aesthetics of Music*
Iain Mackenzie on *Ethics-Politics-Subjectivity*

98 Nov/Dec 1999

Fred Halliday The Twentieth Century
Henry Staten 'Radical Evil' Revived
John Roberts Philosophizing the Everyday
Malcome Bull Hearing the Silence
Kate Soper on *Nature* and *Ecological Values*
Jean-Jacques Lecercle on *Imagining Language*
Harry Harootunian on Anderson on Postmodernity

Subscriptions

individuals: (6 issues) UK £24 Europe £28 ROW surface £30/$49 airmail £36/$59
(12 issues) UK £43 Europe £51 ROW surface £55/$89 airmail £67/$109
institutions: (6 issues) UK £51 Europe £55 ROW surface £507/$91 airmail £63/$102

Cheques payable to *Radical Philosophy Ltd*
Central Books (RP Subs), 99 Wallis Road, London E9 5LN
rp@centralbooks.com http://www.ukc.ac.uk/secl/philosophy/rp

The Slade School of Fine Art

offers the following full-time courses:

BA (Hons) in Fine Art
MA in Fine Art
MFA in Fine Art
Graduate Diploma in Fine Art
MPhil/PhD in Fine Art
Affiliate Courses in Fine Art

for a prospectus and application details please contact:

The Slade School Administrator (Admissions), The Slade School of Fine Art,
University College London, Gower Street, London, WC1E 6BT
telephone: +44 (0) 20 7679 2313 facsimile: + 44 (0) 20 7679 7801
e.mail: slade.enquiries@ucl.ac.uk http://www.ucl.ac.uk/slade/

Pursuing Excellence in Education and Research

byam shaw SCHOOL OF ART

MA in Fine Art
A new one year full time course starting in October 2000

For details please contact

Douglas Allsop Director of Studies

Byam Shaw School of Art 2 Elthorne Road Archway London N19 4AG

T: 0207 281 4111 **E**: info@byam-shaw.ac.uk **W**: http://www.byam-shaw,ac.uk

(subject to validation by the University of North London)

Postgraduate Degrees

We are one of Europe's largest specialist institutions offering programmes in art, design, media and communication. The MA programme provides the opportunity to undertake an extended project on a practical or theoretical aspect of one of the following areas:

Animation, Film & Video, Fine Art, Interior Design, Photography, Graphic Design and **Fashion.**

We also offer research degrees validated by the University of Brighton in **Fine Art Practice and Historical and Theoretical Studies: including Aesthetics; Contemporary Art Theory and Criticism; and Historiography; Film and Television: including Animation; Digital Media; Avant Garde, Experimental and Independent Production; and The European Film and Television Industries.**

For further information or an MA application pack please telephone Registry on **01252 722441,** email **registry@surrart.ac.uk** or visit our web site at **www.surrart.ac.uk**

THE SURREY INSTITUTE OF ART & DESIGN
UNIVERSITY COLLEGE

The Surrey Institute of Art & Design is an exempt charity providing education